IMAGES
of America

WRIGHTWOOD & BIG PINES

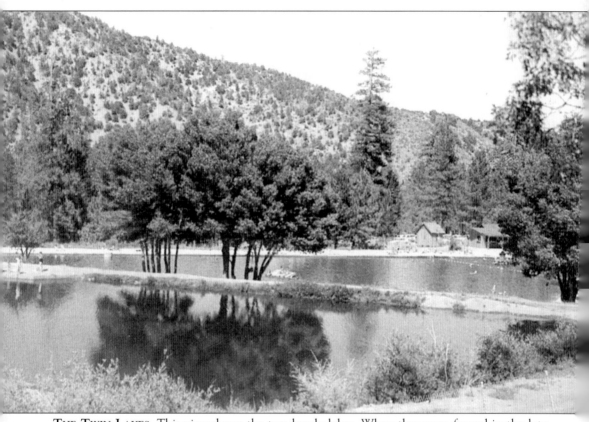

THE TWIN LAKES. This view shows the two lovely lakes. When they were fenced in the late 1940s, teens found a way to slip under the fence and swim at night. (Courtesy Frasher Fotos, Pomona Public Library.)

ON THE COVER: Winter sports enthusiasts enjoy Big Pines. (Courtesy Huntington Library, San Marino, California.)

IMAGES
of America

WRIGHTWOOD & BIG PINES

Pat Krig
Barbara Van Houten

ARCADIA

Published by Arcadia Publishing
Charleston SC, Chicago IL, Portsmouth NH, San Francisco CA

Printed in Great Britain

Library of Congress Catalog Card Number: 2004104600

For all general information contact Arcadia Publishing at:
Telephone 843-853-2070
Fax 843-853-0044
E-mail sales@arcadiapublishing.com
For customer service and orders:
Toll-Free 1-888-313-2665

Visit us on the internet at http://www.arcadiapublishing.com

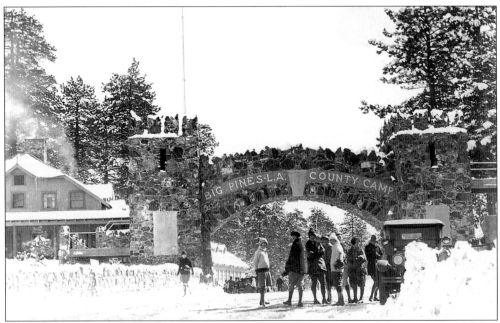

BIG PINES L.A. COUNTY CAMP. Known as "the all-year wonderland of California," Big Pines became one of the foremost mountain recreation playgrounds in the southwest. The park was opened to the public in 1924. (Courtesy Rich McCutchan.)

CONTENTS

DEDICATIONS

Reuben F. McClellan was a man with a vision. As chairman of the Los Angeles County Board of Supervisors, McClellan dreamed of a place where people could leave the city life behind and enjoy the beauty of nature in a mountain setting. His vision and perseverance resulted in the wonderful recreation area known as Big Pines Park. Over the years people traveled many miles to reach this mountain playground, to enjoy the facilities that were made available through McClellan's foresight and political skill. The chapters about Big Pines are dedicated to the memory of R.F. McClellan.

—Barbara Van Houten

G.S. CORPE. As I look at my desk covered with pictures I must say, "Thanks Dad." And I'm compelled to dedicate my efforts to him, Goodspeed Seymour Corpe. A dynamic achiever, he took hundreds of pictures of our mountain home, Wrightwood. Additionally, since he had been a radio operator on ships, his habit was to maintain a daily log, which has been valuable for my research. If Dad approved of this missive, then I have done my job.

—Pat Corpe Krig

INTRODUCTION

Wrightwood, a quaint mountain village, lies in the 6,000-foot-high Swarthout Valley, set among pine trees towering over a rustic setting of homes, shops, and churches. The cool temperatures, the dry air, and the aromatic pines and sage have brought many people to this beautiful valley in the east end of the San Gabriel Mountains.

Swarthout Valley was first homesteaded in 1851 by Mormon brothers Nathan and Truman Swarthout. Their land holdings included Lone Pine Canyon and extended west into the valley that now bears their name—in which Wrightwood is situated. In 1857, when the Mormons returned to Salt Lake City from the San Bernardino area, the Swarthouts abandoned their holdings, which stood idle until 1863 when Almon Clyde, a rancher in the San Bernardino Valley, filed a homestead patent on the Lone Pine Canyon area. He established a cattle ranch and apple orchard, the latter of which is still owned by the Clyde family.

The portion of the old Swarthout property in the valley itself was homesteaded by various individuals between 1886 and 1921. Harry Heath homesteaded the eastern part of the Swarthout Valley in 1886. He ran a dairy and planted orchards. In 1888 Samuel Guffy, a prospector, built a stone cabin and homesteaded in a clearing near a small lake in the middle of Swarthout Valley. Sumner Wright bought 40 acres, including the stone cabin from Guffy in 1890. Wright planted apple orchards and by 1895 owned 3,300 acres and a thousand head of cattle. In 1906 Wright gained control of almost all of the Swarthout Valley when he bought the Heath Ranch. By 1910 Wright was the owner of a mountain estate, which included a successful cattle company, fruit orchards, a stable of fine riding horses, and a lovely home overlooking a small lake.

Unfortunately the good times couldn't last forever. In 1919, due to impending financial problems, the Wrights sold their cattle company to Irving and Emory Kidd. In 1924 Wright subdivided his property into lots for home sites. The proposed new community was advertised in all the Los Angeles newspapers and was named Wrightwood. Thousands came to see, and many bought lots. By 1930 Wrightwood was a thriving mountain community, with a general store, cafe, gas station, post office, lodge, and recreation building. Eventually, Sumner Wright lost all his Wrightwood property to the bank after numerous legal battles.

Today, Wrightwood continues to grow. The population is around 4,500 people, depending on the season. The downtown area consists of small shops, restaurants, lodging facilities, businesses, real estate offices, a library, and a museum. Seven churches are located throughout the community.

Four miles west of Wrightwood is the Big Pines Recreation Area, originally built by Los Angeles County in 1924. During its heyday, Big Pines Park provided year-round recreational facilities that attracted visitors from all over the world, particularly during winter months when world-record ski jumps were made. Winter sports activities were available for people of all ages. Big Pines became a popular place to visit.

Summer months brought throngs of nature lovers to Big Pines Park, where the temperature was cool and the campgrounds were inviting. Many people stayed all summer.

Now administered by the U.S. Forest Service, recreational facilities include camping and

picnic areas, fishing in Jackson Lake, hiking trails, and two ski resorts. The Smithsonian Observatory, built in 1925 on Table Mountain in the Big Pines area, is now operated by the Jet Propulsion Laboratory.

Wrightwood and Big Pines still enjoy four seasons of the year, just as they did back in 1851 when the first settlers came to the valley. This is a wonderful place to come for a day, a week, or for a lifetime.

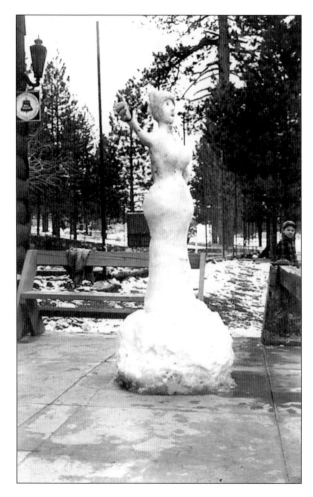

A Snow Lady? This buxom lass was the pride of the high school boys in 1941. Every evening when it got cold enough, Ed Corpe would take a bucket of water and slosh her with it. Surely it prolonged her life. (Courtesy Goodspeed Corpe.)

One
THE STATELY CABINS

The fledgling town, in its earliest days, was fortunate in having three builders with remarkable talent. The first (though not the earliest) that comes to mind is "Clinkscales." The cabins he built are timeless for the beautiful knotty pine paneling, the handsome stone fireplaces, and always an interesting nook or cranny, tucked in somewhere.

The earliest builder was Frank Michaels. His notable home is "Robin Lodge," which is a tribute to his skill. There are many Michaels homes throughout the forest.

Lastly, George Scribner built dream lodges from logs. They all have balconies, and the craftsmanship is so beautiful, one cannot help wanting to touch the hand-rubbed woods.

Thank you, gentlemen, for your legacy.

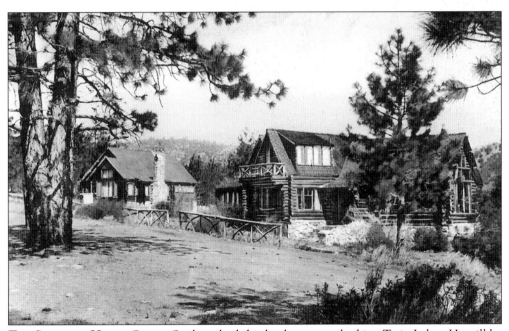

THE SCRIBNER HOME. George Scribner built his log home overlooking Twin Lakes. He will be remembered and revered for his timeless log cabins, reflecting loving craftsmanship. This structure burned in the 1940s and volunteers were almost overcome by smoke while frantically searching for his widow, Ruth. She was not in the house. (Courtesy Rich McCutchan.)

The Gables was a magnificent cabin built in 1930 for the Stoner family, who owned Mack trucks. The contractor was George Scribner, whose preferred construction was chinked logs. The 6,000 square-foot structure had four fire places and was luxuriously furnished with Navajo rugs, leather and log furniture, and animal pelts. (Courtesy Walter Fiss.)

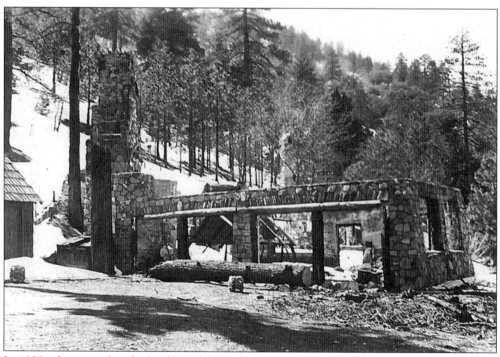

In 1933 a fire started in the kitchen of the Gables. It soon engulfed the entire structure. Flames could be seen for miles. The volunteer fire department, Rod Abbott and Frank Bogert, arrived towing two small tank carts, only to discover that one was empty. The Gables was totally destroyed. (Courtesy Goodspeed Corpe.)

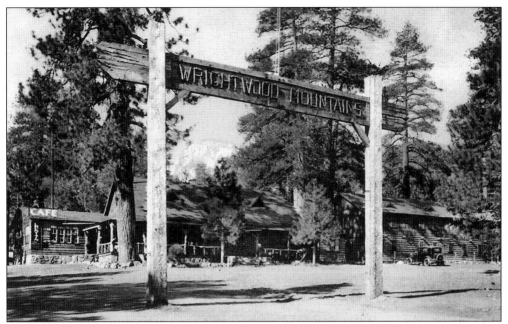

THE RECREATION HALL. The main center of Wrightwood reflected a woodsy charm. The lodge, store, and recreation hall warmly welcomed snow players, weekend cabin owners, and potential buyers of lots. On weekends a fire burned in the fireplace, and one could relax with a cup of hot chocolate. (Courtesy Frasher Fotos, Pomona Public Library.)

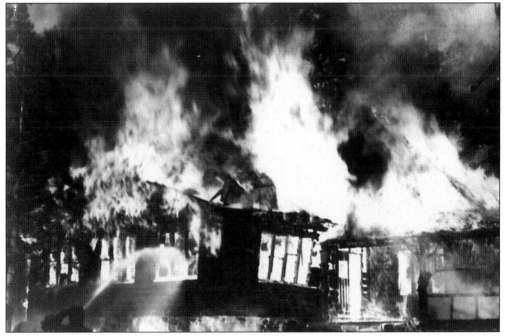

A DEVASTATING FIRE. The recreation hall, which had been beautifully decorated with fresh-cut boughs, burned to the ground on May 31, 1937. The fire apparently started in the kitchen. The entire village heard the fire alarm, and hoses were reeled out, but nothing could stop the conflagration. Fortunately the lodge next door was saved. (Courtesy Goodspeed Corpe.)

VISTA DEL LAGO. This handsome, rustic cabin, owned by the Babcocks, sits high on its lot overlooking the lakes. Many teas and bridge games were enjoyed here by the local ladies. (Courtesy Goodspeed Corpe.)

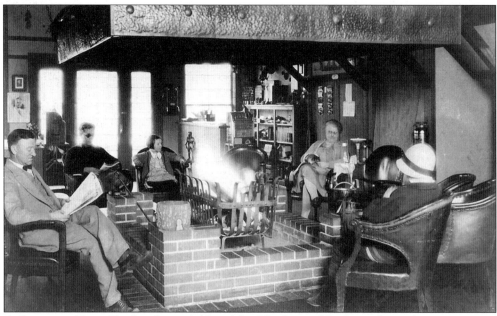

A CHEERFUL FIRE. The handsome lobby of the Wrightwood Lodge welcomed many guests of the lodge as well as local residents of the village, who enjoyed chatting around the unusual central fire place. (Courtesy Frasher Fotos, Pomona Public Library.)

PINON LODGE. This lodge was built in the early 1920s by Buford Wright, nephew of Sumner Wright. Buford was a partner in the Circle Mountain Cattle Company and a ranger at Big Pines. When he made the journey to San Bernardino, he brought a sack of mail upon his return. Thus Buford was the first postmaster. (Courtesy Rich McCutchan.)

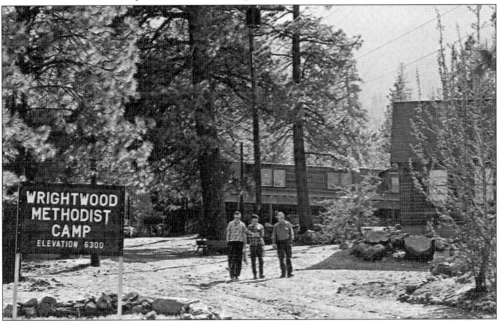

THE METHODIST CAMP. Initially the camp was called the Methodist leader's lodge. Originally the property consisted of a handsome duplex that was the weekend retreat of the Teets and Wilkerson families. It was sold to the church conference. The main lodge burned and was replaced by a more practical dormitory/retreat. Almost every weekend groups enjoy this beautiful setting. Schoolchildren are given field trips here. The camp has a swimming pool and other recreational amenities. (Courtesy Corinne Codye.)

THE SKYLINE FOX FARM. The Schuyler family settled in Wrightwood before their son Ernie married. They raised silver black foxes for fur. In the early 1920s when he was a bachelor, Ernie would walk through the apple orchard to the old stone cook shack and pop in for some of Mrs. Knuckles' vittles. He married Donna, who became the village teacher for Marjorie Michaels and Barbara Faeth. She was paid one dollar a week. Donna also played the piano and helped with entertainment. In the evenings, Donna and Ernie would go below town in his Model T to hunt rabbits to feed the foxes. One would sit on the front fender with the gun while the other drove. The Schuylers raised four boys, who occasionally return to their roots. (Courtesy Pete Schuyler.)

PETE AND JOHN SCHUYLER. On a nostalgia trip to their hometown, the Schuylers presented a beautiful silver black fox stole to the museum. (Courtesy John Aziz.)

14

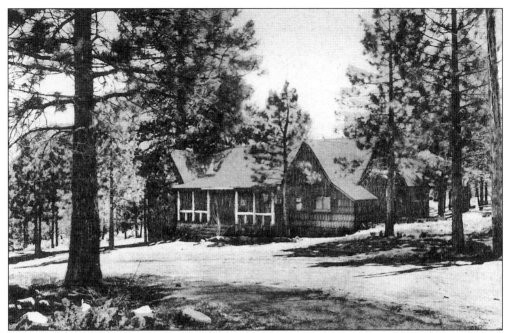

ROBIN LODGE. This large, beautiful home was built by Frank Michaels, an early contractor whose fine craftsmanship is scattered throughout the village. This dwelling had some unique features. The front door has a massive carved tree that welcomes visitors. One entire wall of the kitchen swung open to reveal a bar, complete with brass rail. (Courtesy Rich McCutchan.)

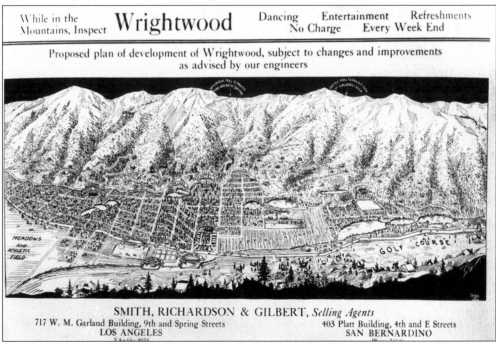

PLAT MAP OF WRIGHTWOOD. The village never became quite as grand as this plat map, but the sales agents could dream, couldn't they? The developers planned a golf course and polo field, neither of which materialized.

SEASONS
Wrightwood is located in picturesque Swarthout Canyon at the 6,000 ft. level on the north slope of the rugged San Gabriel Mountains

AUTUMN

get acquainted with...

WRIGHTWOOD, CA

PROMOTING WRIGHTWOOD. The chamber of commerce in the village, supported by the huge ski resorts to the west (and the bed tax), does a fine job of selling Wrightwood. (Courtesy Wrightwood Chamber of Commerce.)

mere 85 miles from Los Angeles.

Mtn. High on the north slope just 3 miles west of the Village provides the elegancy of a superb day & nite skiing, 11 chair lifts, shuttle buses, and one of the largest snowmaking systems in the Western United States, over 15 miles of ski runs, and several ski shops, ski schools, parking, plus several restaurants.

In addition to skiing many other sports in season can bring you relaxation such as fishing, hunting, hiking, the Pacific Trail has a mail stop at the village post office.

You may enjoy a stroll up park drive and adjacent streets, browse thru the many quaint shops filled with treasure troves of cherishables be it fascinating hand crafted dolls, toll painting antiques, contemporary gifts, fine arts or a bit of Americana and Western with Calico prints, stick candy, spices or coffee from far away lands ground to your liking.

We boast about one of the best Fire Dept's., High School, Post Office and Bank, a community building and several restaurants serving excellent cuisine.

You may worship at the church of your choice and affiliate with the many organizations and service clubs in the Village.

Special Annual Events Calender

July 4 Weekend
Mountaineer Days
Tri Community Art Show
Parade

Sept. - Labor Day Weekend
Chili Cook-off (Nationally Sanctioned)
All Police Rodeo
Arts, Crafts Show
Fireman's Bowl

WRIGHTWOOD BROCHURE. The chamber plans events annually to draw crowds, entertain the weekend visitors, and support local business. They promote parades, an annual car show, and a garden festival. (Courtesy Wrightwood Chamber of Commerce.)

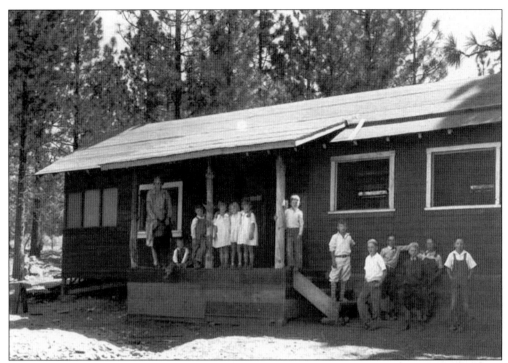

THE LARK STREET SCHOOL. This structure was originally built as a bunkhouse for the Wright ranch and apple farm around 1906. In 1925, the building was moved to its current location and transformed into a one-room schoolhouse for local children. The Lark Street School was in use until 1938. (Courtesy Walt Doan.)

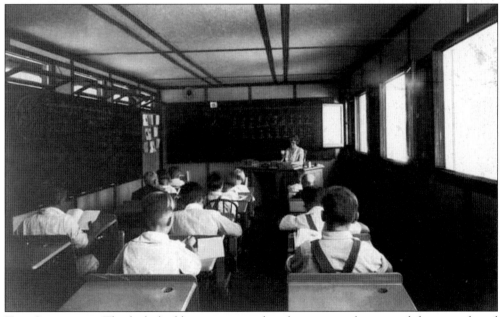

THE CLASSROOM. The little building was spruced up by parents who painted, hammered, and decorated. The Little Rock–Pearblossom school district donated desks, chairs, and the blackboard. The parents arranged to house the local schoolmarm. (Courtesy Walt Doan.)

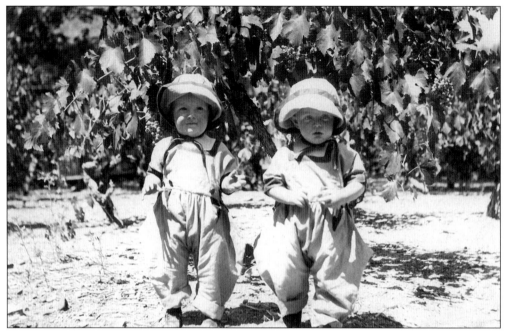

GRANDNIECES OF KATE WRIGHT. Barbara and Virginia Smith loved to visit the ranch. The twins' home was in Colton, but dad Bob Smith was a partner in the Circle Mountain Cattle Ranch. (Courtesy Virginia Hallanger.)

SUMNER WRIGHT AND TWIN GRANDNIECES. The girls grew up loving Wrightwood. Their frequent visits included horseback rides, swimming in Aunt Kate's pond, and wandering far and wide over the sprawling ranch leading a friendly burro. (Courtesy Virginia Hallanger.)

Two

THE EARLY RANCHES

On a venture, with horse and buggy, Sumner and Kate Wright discovered a verdant, beautiful little valley named Swarthout. Wright began acquiring homesteads from earlier settlers, and he and Kate built a sprawling summer retreat on a gentle knoll overlooking a small lake.

Wright partnered with his nephews Bob Smith and Buford Wright in the Circle Mountain Cattle Company. There was ample grazing for about 1,000 head. Wright's other passion was his apple orchard. He continually researched different varieties of apples and their hardiness. In the early 1920s four years of ruinous frost decimated the apple harvest. Additionally, the price of cattle fell below what it cost to raise them. The cattle operation was sold to the Kidd brothers.

Wright decided to subdivide the beautiful pine forest into lots for the building of weekend cabins. Water lines were laid, electricity was generated, and a handsome hotel was built, along with a store and gas station. Folks began to discover the little village. The recreation hall and cafe welcomed travelers who came to buy property. Early cabins were owned by Sears (sales agent for the Wrightwood company), Richardson, Bennett, Fitzgerrell, Prince, Von Ehwegan, Storer, Page, and numerous others. Everyone enjoyed the small lakes, the riding stable run by Rod Abbott, the tennis courts, and the activity at Big Pines, Wrightwood's neighbor to the west.

Many of the streets were named after Kate Wright's relatives—Barbara, Virginia, Betty, Laura, Irene, and Helen.

THE WRIGHT RANCH HOUSE. Kate Wright is seen rocking on the front porch. Kate's brother, Will Van Arsdale, owned and developed a ranch in Willets, California. The ranch was later the home of Seabiscuit, the famous racehorse.

BUFORD WRIGHT AND BOB SMITH. Buford and Bob were part owners of the Circle Mountain Cattle Ranch. The cows ranged from near the Big Pines divide east and north to the Mojave foothills. The economy worsened, and in time it cost more to raise a cow than could be earned by selling it. (Courtesy Virginia Hallanger.)

KATE WRIGHT AND HER TWIN NIECES. Sumner and Kate had no children of their own. They doted on these two darling little tykes and surrounded themselves with friends and family. (Courtesy Virginia Hallanger.)

THE GUFFY HOMESTEAD, 1870S. Samuel Guffy built the small rock house on land he homesteaded. He was primarily a prospector. Sometime later, Guffy longed to return to the Midwest and his family. He sold 40 acres to Mr. Wright in 1890, the year Sumner married Kate. (Courtesy Goodspeed Corpe.)

ENJOYING WRIGHT LAKE IN 1935. From the earliest days of the ranch, youngsters have paddled and splashed in the small lake. Sumner installed a fountain for Kate's pleasure. Horseback riders allowed their mounts to sip and paw the cool, refreshing water. The lake disappeared, and willows and cottonwoods have overgrown the small basin. (Courtesy Goodspeed Corpe.)

BOB AND ROSALIE CLYDE. The Clyde children grew up without neighbors, thus had few chums. They are shown here in 1932 with Heinz, a working dog—and friend. (Courtesy Rosalie Johnson.)

BOB AND ROSALIE CLYDE IN THEIR SWING. "You push me Rosalie, then it's your turn." (Courtesy Rosalie Johnson.)

THE CLYDES

Almon Clyde came to California for the lure of gold. Eventually he bought a house on Sterling Avenue in San Bernardino. Clyde wanted land for farming. He rode into the Lytle Creek area, finding it to be all claimed. He then rode further into the San Gabriel Mountains and found Lone Pine Canyon and the Swarthout Brothers' spread. Two of the brothers had returned to Salt Lake City, but George Swarthout remained on the homestead that had been filed. Clyde purchased the land (the homestead had not been "proven up") for $200 in gold and eight head of cattle. George Swarthout remained on the ranch for the rest of his life.

Almon and Priscilla (Singleton) Clyde had nine children. They left the Sterling Avenue house to Bessie and the ranch in Lone Pine Canyon to the boys. The ranch was divided in 1917, with the lower half going to Fred Clyde and the upper half going to Jerrold Clyde. Albert Clyde was a part owner and lived on the ranch the remainder of his life.

The first building on the ranch was a one-room shanty on stilts, southwest of the Johnson (Jerrold Clyde) home. Later this structure was referred to as the "bee" house—the entire family had an interest in honey bees. The apple trees were planted in 1910 and are famous to this day. A new program, raising sod, was implemented by C.R. "Johnny" Johnson in 1962.

A cabin of great interest to history buffs is situate near the apple packing shed. The Clyde and Earp families were friends, and when this building was built, Virgil Earp helped in the construction. Wyatt Earp probably helped also.

THE ABANDONED STATION. The Clyde Ranch welcomed travelers. To the right of the old station still stand two weathered cedar water tanks. Cool, fresh water cascades over the top and down the sides, creating a cool green oasis. (Courtesy Bob Clyde.)

23

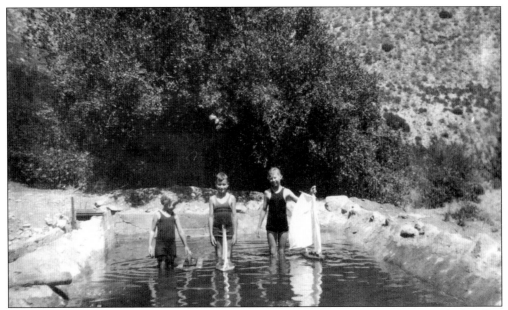

THE CLYDE KIDS AND THEIR POND. With abundant water on the ranch, just a little effort created a wonderful swimming hole. The Clyde Ranch, like the Wright Ranch, is situated atop the San Andreas earthquake fault. (Courtesy Rosalie Johnson.)

BOB AND ROSALIE WITH MORE ANIMAL PALS. Bob rides Annie, and Rosalie, a bit more timid, leads Nanette. (Courtesy Rosalie Johnson.)

ALBERT CLYDE. Albert lived on the ranch his entire life. Here he is shown returning from hunting in the woods. (Courtesy Rosalie Johnson.)

THE SECOND RANCH HOUSE. This old, weathered house sits back off the road, beneath huge cottonwoods. Virgil Earp, and possibly Wyatt Earp, helped build this cabin. (Courtesy Bob Clyde.)

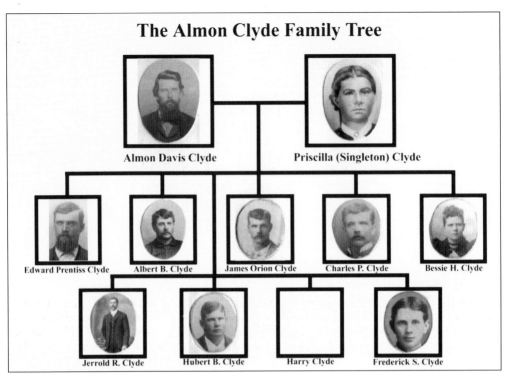

The Almon Clyde Family Tree

Almon Davis Clyde Priscilla (Singleton) Clyde

Edward Prentiss Clyde Albert B. Clyde James Orion Clyde Charles P. Clyde Bessie H. Clyde

Jerrold R. Clyde Hubert B. Clyde Harry Clyde Frederick S. Clyde

THE ALMON CLYDE FAMILY TREE. Almon and Priscilla had nine children. Their house in San Bernardino was left to Bessie. The surviving boys inherited the ranch. (Courtesy Rosalie Johnson.)

BOB CLYDE IN FRONT OF THE OLD FARM HOUSE. Work on a fruit ranch is never ending. In the spring you pray that warm weather won't turn bitter cold. In summer you water, pick worms, and watch the apples turn a blushing red. In the fall, you harvest, and chase deer and ground squirrels, hoping some of your crop will eventually make it to market. (Courtesy Bob Clyde.)

Three
AROUND TOWN

The town has always been fun loving. Visitors and residents alike hung out at the store and at the lodge.
They played on the toboggan slide, ice skated, rode horseback, hiked, swam, hunted, and fished. Lee
Marvin, the well-known actor, owned a stately old lodge, and loved to ride motorcycles with the locals.
The Yodeler, a favorite watering hole, has appealed to the "touring crowd" for 40 years.

THE WRIGHTWOOD STORE. The old building was the supermarket, hardware store, post office,
and cafe in the 1920s and 1930s. It is uncertain whether there was a pickle or cracker barrel, but
invariably there was Aldous Huxley standing on the porch expounding on the evils of liquor.
The rooms above the store were the town's first chapel. George Richardson was the affable
owner/clerk. (Courtesy Rich McCutchan.)

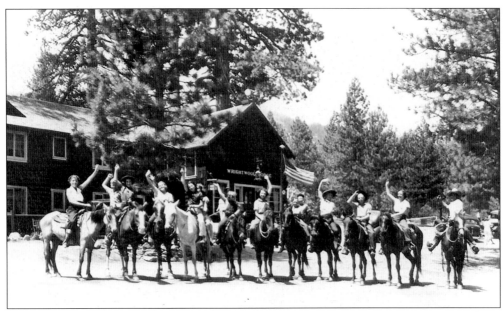

HORSEBACK RIDERS AT THE LODGE. Riding the trails through pine forests was a refreshing experience. The wise old ranch horses were gentle and safe. (Courtesy Goodspeed Corpe.)

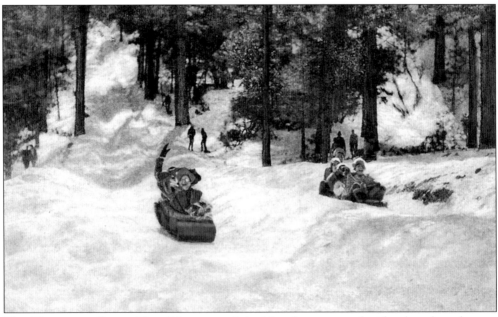

THE TOBOGGAN SLIDE. The slide was graded with a berm on each side; thus the toboggan followed the track. When the slide was first completed, *c.* 1926, Amos (who constructed the slide) and Lena Robinette, along with Judge Nix and his wife, all tried out the slide on a moonlit night. (Courtesy Rich McCutchan.)

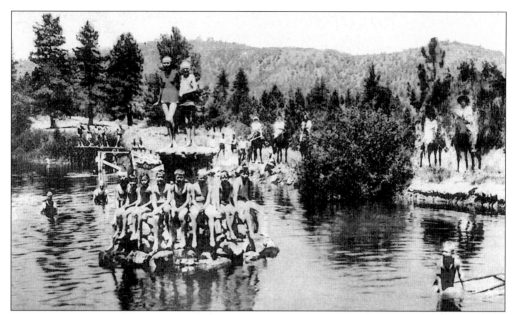

THE FOUNTAIN AT THE LAKE. Campers, cabin owners, and horseback riders all enjoyed the largest of the sag ponds. The lakes have been the center for sports and entertainment since the village was subdivided. Originally there were two lakes (thus the name Twin Lakes Drive). The upper lake was occasionally stocked with trout, with an occasional goldfish thrown in. The lower lake was "the swimming hole." In winter, usually around Armistice Day, the lake froze and was used for skating. A fire would blaze on the shore, where skaters could rest and roast a marshmallow or a hot dog. (Courtesy Rich McCutchan.)

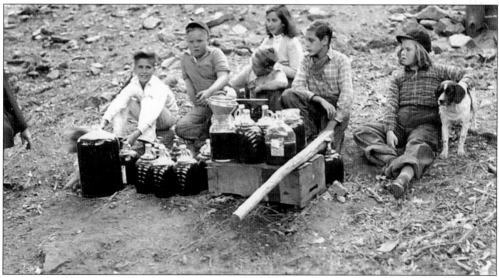

AFTER THE PRESSING. In the fall after the first frost, the villagers gathered up by the old packing shed, then roamed through the ancient orchard and gathered the apples that had fallen from the trees (worms and all). The men did the pressing, and delicious cider was bottled and divided among the villagers. Harvey Hunt, an early resident, always took his share home and buried it. It was opened with great ceremony over the holidays, and Harvey's famous apple jack was enjoyed greatly. (Courtesy Goodspeed Corpe.)

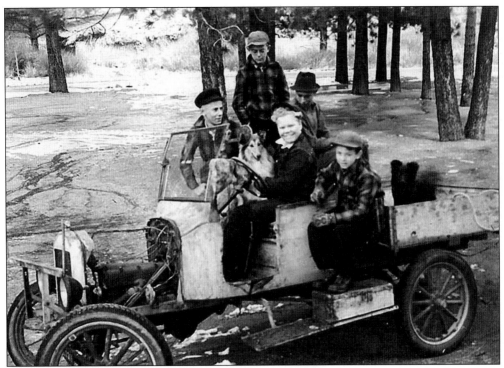

EDSEL CORPE. G.S. Corpe, Ed's dad, had been a Ford dealer in Model T days. G.S. knew Henry Ford and named his son Edsel after Edsel Ford. This old wreck was purchased for five dollars. The boys painted it bright blue using a broom! It was quite a challenge to motor around the mountain. Because the gasoline was "gravity feed," Ed had to back up the hills. (Courtesy Goodspeed Corpe.)

SLEDDING AT WRIGHTWOOD MOUNTAINS. Young ladies enjoy the exhilarating sport of sledding during an early snow. This pleasant pastime was great fun in early days. Currently there is so much traffic it has become hazardous to sled on the village streets. (Courtesy Goodspeed Corpe.)

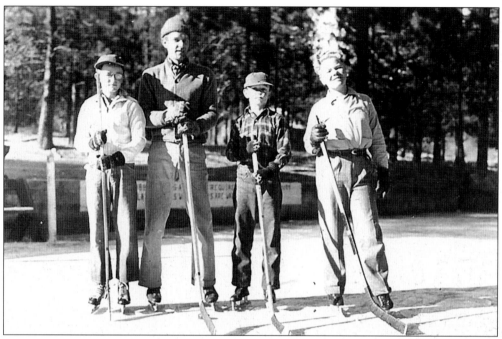

QUITE A HOCKEY TEAM. The boys are planning a game of hockey on the frozen (flooded) lodge tennis court in 1939. They would come home from school, spray more water over the court, then have a rousing game of hockey. When they tired of hurting one another, the girls could practice figure skating. (Courtesy Goodspeed Corpe.)

SLEDDING FOR TWO. Marian Moore and an unidentified friend enjoy the newly fallen snow in this 1934 photo. Since the family's weekend cabin was nearby, being cold and wet could soon be alleviated. (Courtesy Goodspeed Corpe.)

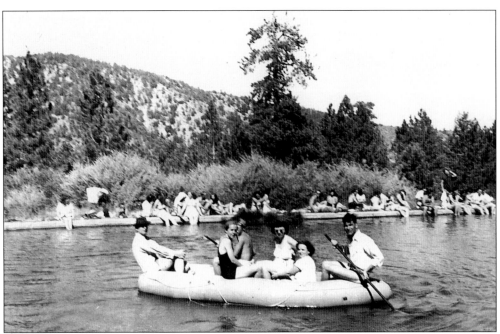

FUN AT THE LAKE. Campers from the Methodist leader's camp inflated their rubber raft for a day of fun on the lower Twin Lake in the 1940s. (Courtesy Corinne Codye.)

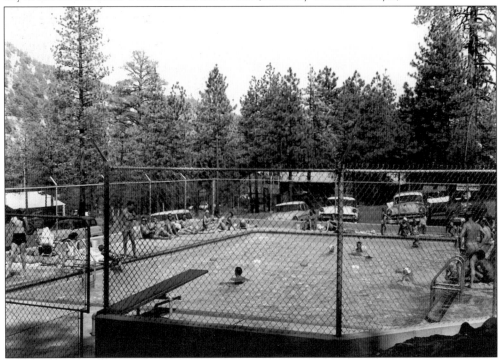

THE SEAHORSE POOL. In 1956 Dan Burns, a fine mason, built a beautiful swimming pool right in the heart of town. All the local children took lessons from Dan's wife, Joan. When interest began to wane, Dan simply closed the pool, drained it, and built on top of the pool a building that now hosts the county library. (Courtesy Dan Burns.)

THE SINGING COWBOY: GENE AUTRY, 1939.
Lynn MacDonald and author Pat Krig were
thrilled when they discovered this movie filming
on location in the mountains. Just to be allowed
to pet Gene's horse Champion was a treat.
(Courtesy Pat Corpe.)

AUTHOR PAT KRIG AND HORSE. Gene Autry's
horse Champion gives Pat a laugh. Leslie
MacDonald, the father of Lynn MacDonald, was a
cowboy on the Wright Ranch before becoming a
ranger at Big Pines and was just as horse crazy as
Pat. (Courtesy Pat Corpe.)

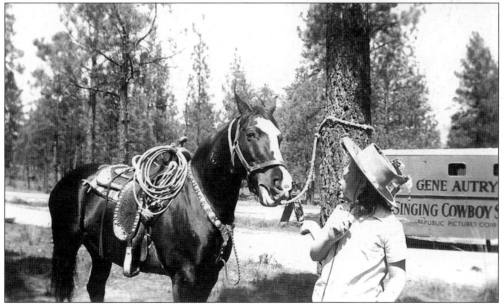

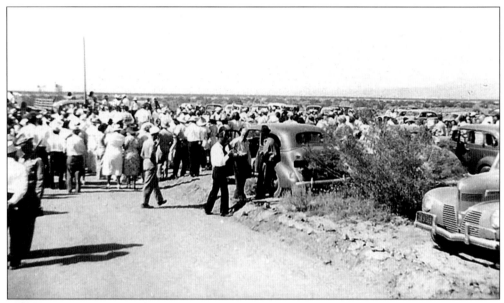

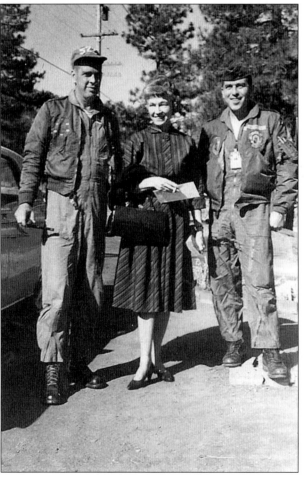

OPENING CEREMONIES.
Victorville Army Air Field was formally activated July 12, 1941. Wrightwood has always beckoned to young Air Force officers. The sight of the beautiful mountains in the distance and the lack of housing on the desert at that time lured them here to make a home before they were sent overseas to fight. The lobby of the lodge became somewhat of an "officers' club." When payday arrived, there would be friendly blackjack games, bridge, poker, and chatter. (Courtesy Goodspeed Corpe.)

AIR FORCE OFFICERS. Maj. Harry Krig, Hildred Corpe, and Capt. Ernie deSoto are pictured here in 1960. Though stationed in New Mexico, the pilots made a trip to George Air Force Base (the new name of Victorville Army Air Field) and were able to visit Wrightwood for a few hours. (Courtesy Goodspeed Corpe.)

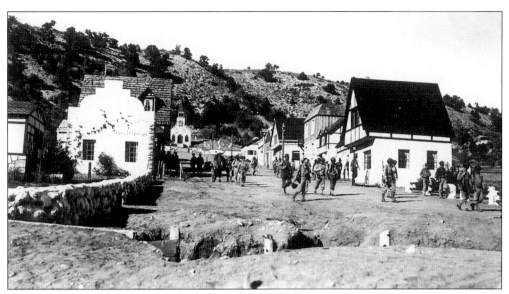

GERMAN VILLAGE VISITED. In 1943 the author and a friend rode into the Big John valley and were completely flabbergasted! "Annadorf," as the mock village was named, was a cluster of make-believe buildings complete with wooden silhouettes in windows, a church, a town square with a tiered fountain, and a schoolhouse. (Courtesy Fred Moulton.)

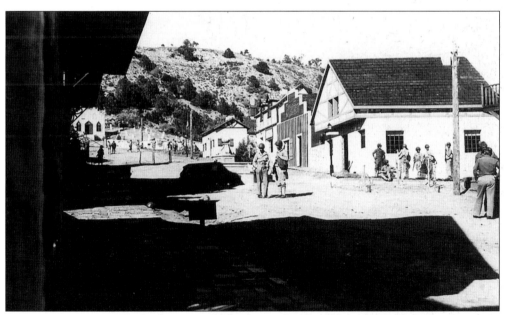

GERMAN VILLAGE. Nine miles west of Wrightwood situated on a narrow dirt track was an old movie set—unused, overrun with ground squirrels, packrats, and jackrabbits. In 1943 the U.S. Army saw the need to train the troops to fight in villages in Europe. The abandoned set was purchased for $1,400, and a talented crew led by a Major Smillie began to build a mock German village. Master Sgt. Arto Monaco (a former animator) designed the project. (Courtesy Fred Moulton.)

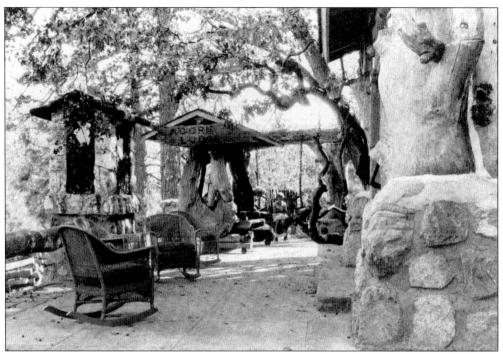

AN INVITATION TO RELAX. The delightful prose of William Bristol's book offers, "This is the terrace, wide and long, with seats enough for a goodly throng." (Courtesy Walter Fiss.)

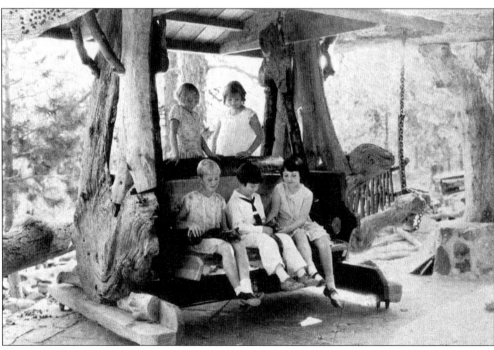

CHILDREN ENJOYING A COOL AND SHADY RETREAT. A curious piece of wood forms the major portion of each end of this massive swing. (Courtesy Walter Fiss.)

Four
ACORN LODGE

Acorn Lodge is a unique and imaginative testimony to William Bristol, the inventive entrepreneur who also wrote a whimsical book entitled The House That B Built in 1929. Bristol used an unusual method in the construction of his lodge, resting it on massive oak beams, and Bristol himself, though in his seventies, did much of the stone masonry work that enhances the lodge's exterior. Acorn Lodge was formally opened to the public on November 4, 1928 with a program that consisted chiefly of a welcome address by Bristol, a flag-raising ceremony, a parade led by Barbara Faeth (Robertson), and stirring band music by the Redlands American Legion Drum and Bugle Corps.

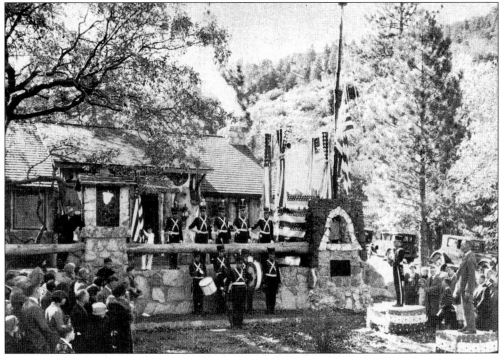

OPENING CEREMONIES. This beautiful mountain lodge was built by retired orange grower William Bristol during 1926 and 1927. The structure was completed in 1928 and opened to the public.

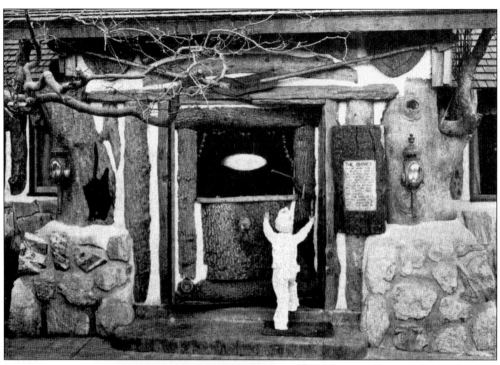

THE MASSIVE ENTRANCE TO ACORN LODGE. Pictured here in 1932, the door itself is five and one-half feet wide, seven feet high, and weighs 600 pounds. The lamps adorning each side came from a stately coach in San Diego. (Courtesy Walter Fiss.)

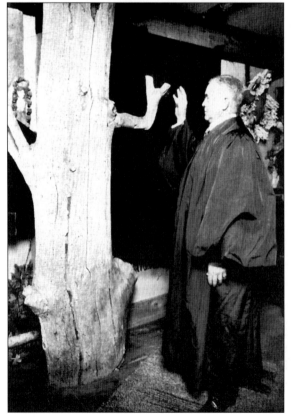

SWEARING-IN A PROUD POST. At each side of the entrance to Acorn Lodge stands a weathered oak log. This one has a limb closely resembling an uplifted arm and hand. Justice Jesse William Curtis of the California Supreme Court is jokingly administering the oath in 1930. (Courtesy Walter Fiss.)

GARGANTUAN YUCCA. In the April 1929 issue of *Touring Topics*, published by the Automobile Club of Southern California, William Bristol, of Acorn Lodge fame, contributed an article on the yucca whipplei, California's most spectacular wild flower. This picture accompanied the article. (Courtesy Walter Fiss.)

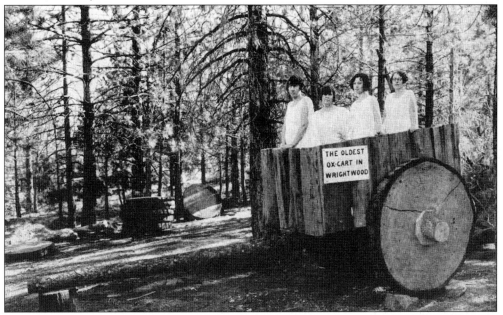

THE OLDEST
OX-CART IN
WRIGHTWOOD

THE "ALMOSTA" OX CART. In towns all over the West, there is a story about the "oldest cart in America." This one, pictured *c*. 1928 with four unidentified ladies, is in fact the oldest cart in Wrightwood. (Courtesy Walter Fiss.)

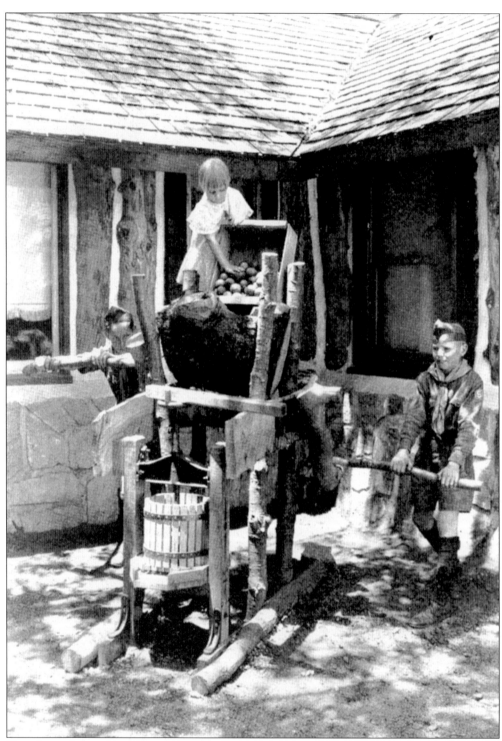

THE CIDER MILL. Useful as well as ornamental, the large cider mill pictured here is made of oak. The elevation of this mountain home (and its mill) is 6,200 feet, so high that late-spring frosts often freeze the blossoming trees, making for an even tastier cider. (Courtesy Walter Fiss.)

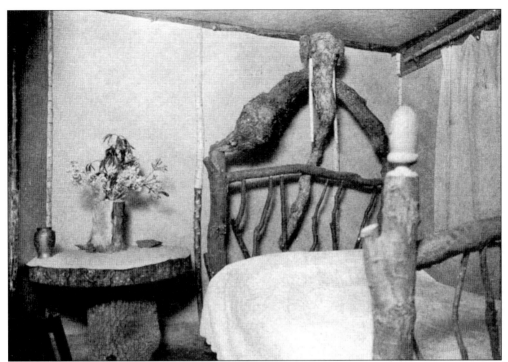

FURNITURE. William Bristol, who built Acorn Lodge, gathered wood from the Wrightwood mountains to create furniture for his home. Above is the "Animal Beadstead," which is topped with a piece of wood resembling an elephant's head, and below is the "Acorn Mirror." The bed in the "Acorn Room" below is made from the wood of the elderberry, which in California grows to be a tree. (Both courtesy Walter Fiss.)

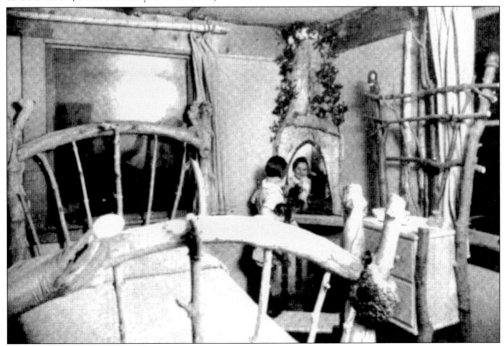

THE HONEYMOON CABIN. Sheltered in the oak forest, nine sturdy young oak trees were expanded by jackscrews and block and tackle, into a perfect eight-by-ten-foot rectangle. Because it was first occupied by a bridal couple it became known as the Honeymoon Cabin. A drawbridge stairway leads up to it. This stair, hinged and counter-weighted, pulls up behind the retiring couple. (Courtesy Walter Fiss.)

Five

IN AND AROUND

Over the years, much has happened in the small community of Wrightwood. Festivals and celebrations have been held, civic organizations established, and people have raised their families. Contributing to the continuing story of Wrightwood were such residents as the Sears family, the Knuckles family, the Princes, and the Richardsons; and early teachers including Mrs. Baker, Miss Colgan, Mrs. Campbell, Miss Franklin. Wrightwood even had a few local "characters" over the years—Kay Mullendore, Esther Steadman, and Aldous Huxley.

In this chapter, readers will see a variety of images that represent daily life in Wrightwood over the years. From Mountaineer Days and Fourth of July parades to familiar faces and historical structures, these photographs pay tribute to the unique story of Wrightwood and its citizens.

PRESIDENT OF THE WRIGHTWOOD HISTORICAL SOCIETY. John Lenau and his wife, Allene, show off the restored fireman's quarters upstairs in the Old Firehouse Museum. Many society members pitched in to make the tired old room look fresh and inviting. A meal of "make-believe" food was even laid out as if the on-call firemen had just dropped everything and rushed to a fire. (Courtesy Wrightwood Historical Society.)

43

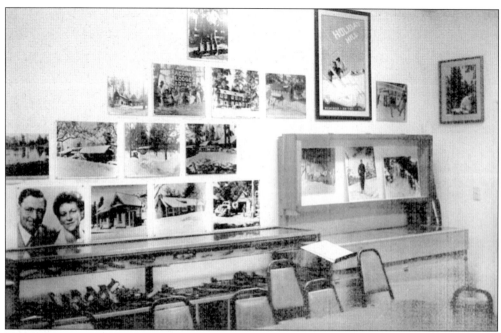

THE FIREHOUSE MUSEUM. The museum collection covers almost everything pertinent to the village. A portrait of Judge and Mrs. Nix is visible, along with a ski poster of Holiday Hill (now Mountain High East). Proudly displayed is the only painting remaining from Bristol's Overland Trail exhibit. A silver black fox stole, donated by the Schuylers, and a little chair from the Circle Mountain Cattle Ranch office are also interesting additions. (Courtesy Wrightwood Historical Society.)

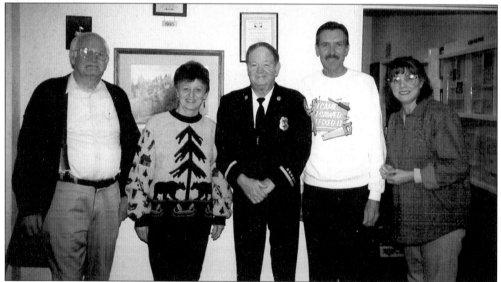

SOCIETY MEMBERS AND GUEST. George Tillitson, Barbara Van Houten, retired Fire Chief Bob Hedden, John Lenau, and Norma Rasmussen pose after a meeting in which Chief Hedden recounted the history of the fire department. In a wooded area such as Wrightwood, fire suppression and well-trained firefighters are all-important. (Courtesy Wrightwood Historical Society.)

DEDICATION OF THE MURALS. The huge blank doors of the Old Firehouse Museum inspired local artists Sue Fullerton and Karen Jordal to paint images of two aged fire trucks on them. Always looking for a party, the society held a grand dedication. Many members and local residents came to thank Karen and Sue. An antique fire truck, owned by Roy Moore, was carefully displayed.

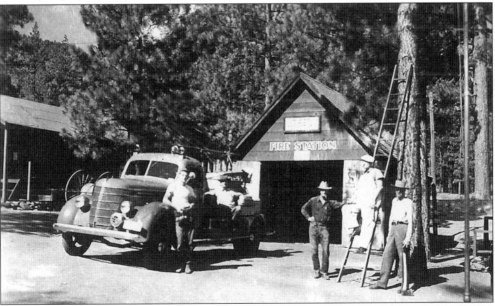

THE FIRST FIRE STATION, 1948. From left to right are two unidentified men, Chief Al King, Dale Crout (later chief), and Bill Haney. The ladder was in place to install a more effective alarm. The first fire alarm in the village was a huge discarded saw blade, hung in this tree. In order to rouse the volunteers, one grabbed a baseball bat or a limb and banged on the blade. No wonder the early cabins burned to the ground once a spark ignited them. (Courtesy Goodspeed Corpe.)

FRANCES YARNALL. Frances was president of the historical society for many years and was the driving force behind obtaining the unused firehouse for the society's museum. In this picture, she celebrates her 90th birthday. (Courtesy Wrightwood Historical Society.)

DR. HORN AND FRANCES YARNALL. Frances presides over a meeting of the Wrightwood Historical Society. Society meetings were held in the old firehouse, which now is a museum. Prior to obtaining the building, the society met only in members' homes. (Courtesy Wrightwood Historical Society.)

JIM PRINCE AND FRANK BOGERT.
Jim Prince's family came to
Wrightwood in the early days right
after the ranch became a town. Jim's
dad, Herb, was very civic-minded. He
ran cakewalks and donated money
when it was needed for the fledgling
town. Frank Bogert helped Rod
Abbott run the stable. Frank's dad,
Harry "Pop" Bogert, helped on the
ranch. Pop played the banjo and
presided over many campfires. Frank
left for greener pastures in Palm
Springs. He was friends with many of
the movie crowd and later was
elected mayor of Palm Springs.

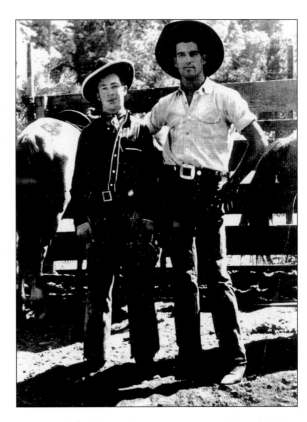

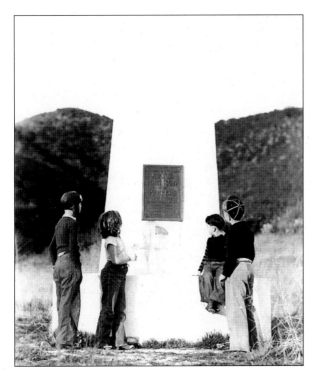

AT THE PIONEER MONUMENT.
These youngsters learn about the
1850s Mormon trek, which went
from Salt Lake City to San
Bernardino. This site in Devore
commemorates that wagon train.
(Courtesy Goodspeed Corpe.)

LANCE WITH HIS CHAINSAW. Author Pat Krig's youngest son was fascinated with woodmen. His father made this toy chainsaw for him, and Lance tried in vain to cut down every tree in town. (Courtesy Pat Corpe.)

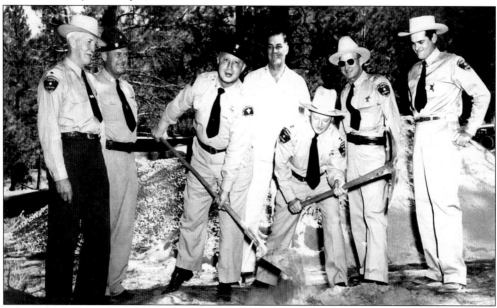

THE SHERIFF'S RESERVE. Members of the Sheriff's Reserve break ground for a new sheriff station *c.* 1957. Amos Robinette donated the land, and Joe Meluso, a local contractor, built it from split logs. The men in the picture, from left to right, are Lyman Mason, who was postmaster; Leers; Muller; Cy Copper; Percy Bennett; and Wurzburger. Standing on the right is contractor and reservist Bill Orr.

DORIS GOODSPEED AND REPRESENTATIVE OF THE PTA. Doris Goodspeed, principal and teacher of the upper grades, receives the lifetime PTA achievement award. Doris was married to a World War I fighter pilot. She later married Bill Goodspeed, who started a local ambulance service using an old Cadillac hearse. Doris's son Ed C.J. Thomas was with the Sheriff's Department. Ed married Dillie Giberson, and they were presented with the deed to Ed's grandfather's house as a wedding present. Dillie is a nationally known artist, and Ed is a talented musician.

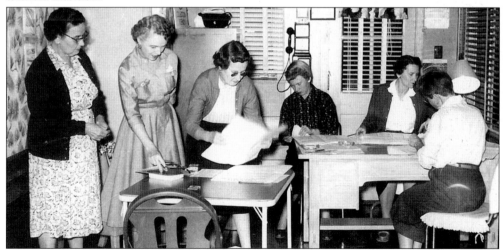

THE ELECTION BOARD. The Corpe real estate office on Highway 2 was the polling place. The board members in this picture, from left to right, are Hilda Holmes, Hildred Corpe, Eunice Christiansen, Louise Dibble, Irma Waag, and an unidentified person. Hildred Corpe was the registrar of voters. A standing joke in the conservative, Republican family was that if a liberal Democrat came in and tried to register to vote, Hildred would lecture them, then reluctantly register them. (Courtesy Goodspeed Corpe.)

DOROTHY THOMPSON NOWKA. Dotty owned the Blue Ridge Inn and often did the bartending. She was from Chicago and loved jazz. The inn was closed on Tuesdays, when Dot and husband Tex would often drive to the Chi Chi Club in Palm Springs to hear Louis Armstrong. The three gentlemen pictured are Air Force officers.

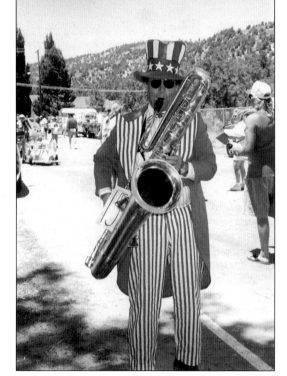

MAKE-BELIEVE UNCLE SAM. Larry Cermak patriotically marches in a Fourth of July parade while his alto sax gets heavier and heavier. Larry is the superintendent of Silverwood Lake, a state recreation area. (Courtesy Pat Krig.)

THE CORPES. Goodspeed and Hildred Corpe were married in 1925 at the Mission Inn in Riverside, California. In 1937 they moved to Wrightwood, where they owned a weekend cabin. Both were involved in civic affairs, working with the chamber of commerce, the PTA, the election board, and others. (Courtesy Susan Gates.)

LEACHING AND SHOVELING MUD. A flood (8 inches of rain in 15 hours) devastated Southern California in 1938. Tons of mud washed down the roads of Wrightwood, broke in the French doors at the rear of the lodge lobby, then oozed downstairs and flooded many guest rooms. The next morning, many villagers arrived to help flush out the gooey mess. Ed Corpe and Frank Burson carried dozens of wheelbarrow loads out. Wrightwood's new Highway 2 (completed in 1937) was totally impassable, and phone lines and electricity were out. The only means of communication was Corpe's shortwave radio set, along with his private generator that had enough power to run the set. (Courtesy Goodspeed Corpe.)

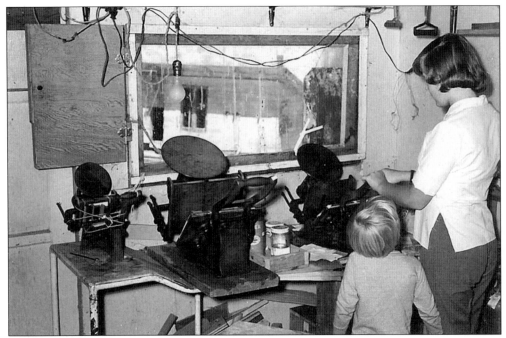

GRETCHEN AND TINA CORPE. Gretchen and Tina get the feel of Grandpa Corpe's printing presses. He gladly donated hundreds of hours setting type and printing tickets, hand bills, and Christmas cards. Postcards were made from photographs he had taken, and the backs were printed with Wrightwood information. All the family pitched in to jog the dried articles, count, stack, and—a task not relished—clean the type and the presses. (Courtesy Goodspeed Corpe.)

40c *ADMIT ONE ADULT* 40c

WRIGHTWOOD CHAMBER OF COMMERCE FIRE FUND BENEFIT

Entertainment - - Refreshments

December 9, 1939, 8:30 p.m., Big Pines Recreation Hall

Program through the courtesy of Mrs. Norman Amland

TICKET PRINTED ON ONE OF CORPE'S PRESSES. Goodspeed Corpe donated many hours turning out village printing. He wasn't very religious, but even the Catholic priest had him setting type.

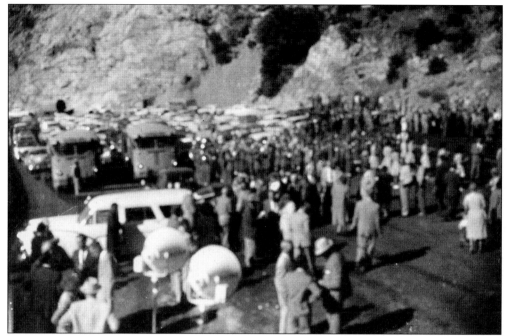

THE OPENING OF HIGHWAY 2. November 8, 1956, saw a huge crowd deep in the San Gabriel mountains at the official opening ceremonies of the long-anticipated Highway 2. This road cut the distance to La Canada by approximately 40 miles. However, the time it takes to drive the winding road is no less. (Courtesy Goodspeed Corpe.)

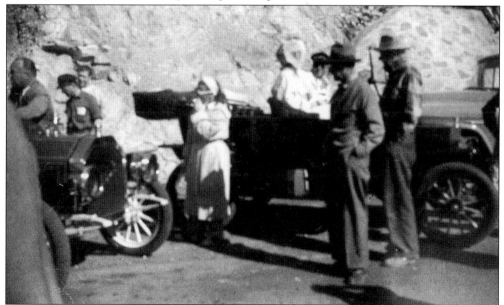

A SCENIC DRIVE. Members of the Horseless Carriage Club drove their restored automobiles to add some style to the Highway 2 opening ceremonies. This beautiful, scenic highway is especially loved by motorcyclists. The road winds past Vincent's Gap, through Mt. Waterman and Kratka Ridge ski resorts, past Chilao Flat, and down to La Canada. (Courtesy Goodspeed Corpe.)

WRIGHTWOOD SCHOOL BOARD AND PTA, 1938. From left to right are Mrs. Corpe, Hunt, MacDonald, three unidentified people, Rowe, and Page. Kneeling is Sears. These ladies were a formidable group of "movers and shakers." The ladies held cake walks and box auctions and/or simply badgered the menfolk into providing what was necessary. (Courtesy Goodspeed Corpe.)

FIRST EDITOR OF THE MOUNTAINEER. Barbara Robertson, editor of the local newspaper, did a great job of covering the village. The only other identified person in the group, with Barbara on the left, is Ernie Seeger, a wealthy industrialist, on the right. Barbara, an early resident of Wrightwood, led the parade to Acorn Lodge in 1928 when it was opened to the public. (Courtesy Goodspeed Corpe.)

ADMIRING A DISPLAY OF ANTIQUE TOOLS, 1948. From left to right are an unidentified person, Hildred Corpe, Fire Chief Jim Prince, and an unidentified person.

LARRY LANGE. Longtime resident Larry Lange, pictured here with his sons Scott and Michael around 1970, has been providing wood for Wrightwood residents for 40 years. (Courtesy Goodspeed Corpe.)

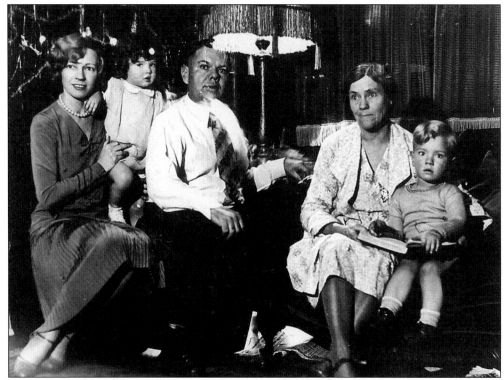

THE YOUNG CORPE FAMILY, 1931. From left to right are Hildred, Patricia, Goodspeed, Mother Corpe, and Edsel.

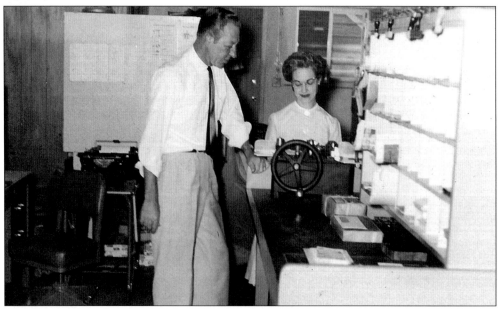

OUR POSTMASTER. Bud Vehrencamp and Ruth Robinette Clark are shown in the old post office on Cedar Street. Bud was the Wrightwood postmaster from 1961 to 1981. His wife, Jane, was secretary to the Wrightwood Company. (Courtesy Goodspeed Corpe.)

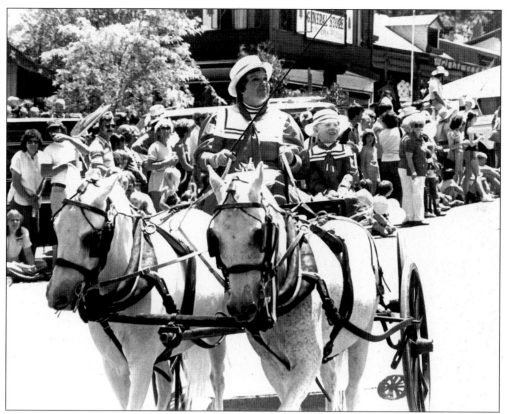

Two Very Patient Ponies. Pat Corpe and granddaughter Sami drive Surprise and Dolly down Park Drive in a Mountaineer Days parade in the early 1980s. The ponies also pulled Cinderella's coach at Disneyland. (Courtesy Tom Pinard.)

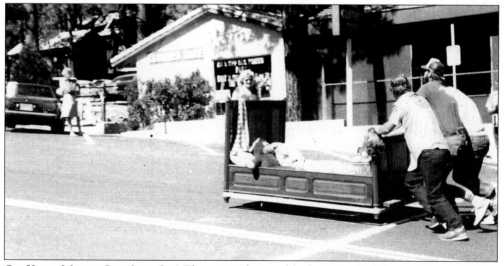

On Your Mark, Get Set, Go! The original annual bed races, which began around 1980 as part of the Mountaineer Days festivities, required actual beds. This antique entry is a bed from the Wright Ranch house. Wearing slumbertogs and riding in the bed, complete with stuffed toys, is Andrea Farrell, c. 1984. Modern races allow such "fake beds" as tungsten gurneys!

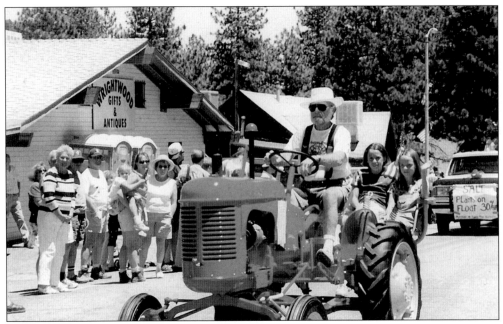

CELEBRATING THE FOURTH. A large crowd watches the annual Fourth of July parade as it heads down Park Drive. The steep route can cause some anxious moments. This photo shows Don Bowman, a former gas company emloyee, and his granddaughters, Aubrey and Carissa, with his restored 1948 tractor. Don engineered a "rumble seat" from a ski lift chair that bolts onto the beautiful little tractor. (Courtesy Don Bowman.)

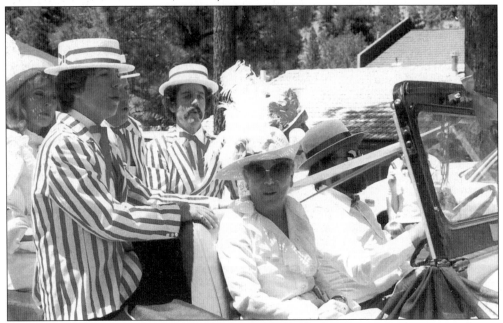

LORRAINE JOSLIN AND ENTOURAGE. Lorraine Joslin was a prominent vocal music teacher in the Fontana school district in the 1960s and 1970s, and her vocal groups performed far and wide. Joslin was also an amateur ham-radio operator. She is joined here by a barbershop quartet in a winning parade entry around 1976. (Courtesy Bill Hillinger.)

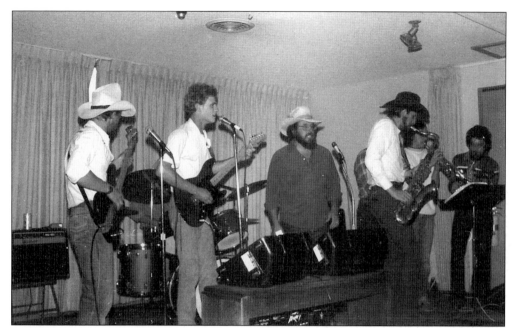

THE JOHN BURCHER BAND. Pictured in the 1970s, from left to right, are Greg Schloesser, Eric Magnusun Jr., Larry Dahlke, John Burcher, two unidentified musicians (mostly hidden), and Tommy Boyles. Burcher, a talented musician, entertained at many affairs, both large and small. (Courtesy Bill Hillinger.)

FUNDRAISING IS FUN. Shown, from left to right, at a 1950 barbecue fundraiser are author Pat Krig, Joe Meluso, Eunice Christiansen, an unidentified person, Grace Meluso, and an unidentified person in back. The hard work paid off handsomely. More than $600 was raised for the fire department.

BARBECUE CHICKEN, ANYONE? Not only do Wrightwood residents enjoy parades and all entertainments, but they like to eat! These chickens look about ready to be consumed with great gusto. (Courtesy Bill Hillinger.)

TROOPS POSE FOR A NOSTALGIC MOMENT, C. 1942. An Air Force officer with his twin daughters stands beside the 1898 Sears Roebuck gasoline buggy owned by G.S. Corpe. Ginger, the collie, poses beside the unidentified driver. Author Pat Krig rides Cyclone, one of the family's horses. (Courtesy Goodspeed Corpe.)

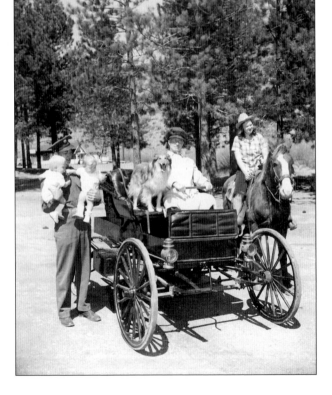

STAGING A MUSICAL. The effort staging *South Pacific* was certainly worth it. The entire town was required to play the cast and staff the support. Hardly anyone was left to be the audience. (Both courtesy Bill Hillinger.)

THE WRIGHTWOOD COMMUNITY PLAYERS
present

SOUTH PACIFIC

Music By: Richard Rodgers

Lyrics By: Oscar Hammerstein, II

Tom Thorne Auditorium
Wrightwood, CA

Produced By: Jerry Howe
Directed By: Diane Byron

THE CHARACTERS
(in order of appearance)

NGANA	Lisa Benson
JEROME	Aaron Justice
ANDRE	Colin Milburn
HENRI	Dennis Williams
NELLIE FORBUSH	Kathy Hartzog
EMILE de BECQUE	Dick Lewis
BLOODY MARY	Stephanie Dahlbeck
BLOODY MARY'S ASSISTANT	Joye Geertson
STEWPOT	Jerry Howe
LUTHER BILLIS	Jerry Walde
PROFESSOR	Bob Jones
LT. JOE CABLE	Dan Amberg
CAPTAIN BRACKETT	Fred Hanrahan
COMMANDER HARBISON	Russ Richardson
YEOMAN QUALE	Rick Stroik
SEABEE WISE	Jim Corliss
RADIO OPERATOR McCAFFREY	Dennis Williams
MARINE CPL STEEVES	Russell Bryant
LIAT	Renée Milburn
LT. BUZZ ADAMS	Gary Martin
NURSES: JANET	Valerie Phillips
LISA	Judi Justice
DINAH	Casejoy Cline
RITA	Ocia Bryant
SUE	Suzanne Oliver
CONNIE	Becky Schnack
ISLAND GIRLS:	Laurie Hartzog
	Kerrie Cargill
	Kristie Cargill
	Shelly Lussier
	Julie Drew
	Mary Jane Orr
BONGO PLAYER:	Dennis Williams

MUSICAL NUMBERS
ACT I

Dites Moi	Jerome, Ngana, Andre
Cockeyed Optimist	Nellie
Twin Soliloquies	Emile, Nellie
Some Enchanted Evening	Emile
Bloody Mary	Sailors
There Is Nothing Like A Dame	Sailors
Bali Ha'i	Bloody Mary
Bali Ha'i	Cable
I'm Gonna Wash That Man Right Out Of My Hair	Nellie, Nurses
Some Enchanted Evening	Nellie, Emile
I'm In Love With A Wonderful Guy	Nellie, Nurses
Bali Ha'i	Native Girls
Younger Than Springtime	Cable
Wonderful Guy (Reprise)	Nellie, Emile
This Is How It Feels	Nellie, Emile
I'm Gonna Wash That Man Right Out Of My Hair	Emile

ACT II

Happy Talk	Bloody Mary
Honey Bun	Nellie, Billis, Nurses
Carefully Taught	Cable
I Will Cling To This Island	Emile
This Nearly Was Mine	Emile
Some Enchanted Evening	Nellie
Dites Moi	Jerome, Ngana, Andre, Nellie, Emile

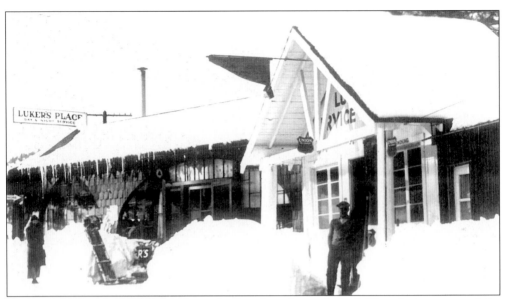

LUKER'S PLACE. One could get lodging, food, and gasoline at Luker's Place. Luker managed the Wrightwood Lodge, but after he and Wright had a falling out, he left and constructed these buildings across Highway 2 around 1930.

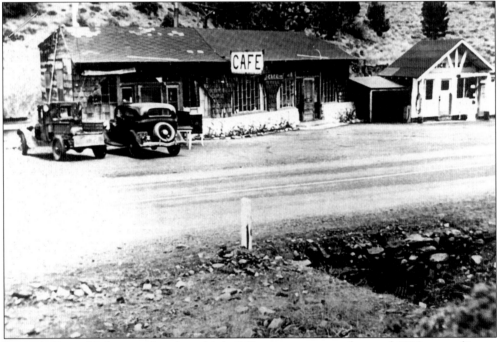

LUKER'S CAFE. Unfortunately, when this building was constructed around 1930, part of it was over the property line and on the right-of-way purchased for the trackless trolley. Wright sued, and Luker was forced to lop off a corner of the building.

THE WAYSIDE CABINS. Luker constructed these miniscule shacks for people to rent for a night or two. They had screened, canvas sides, hard cots, and no running water. In front is a snow-dusted, swampy area. The Wayside Cabins saw tragedy one day around 1939 when a little girl came outside to feed her dog. When she bent over with the pan of food, a stray bullet from a deer hunter's rifle struck and killed her. These shacks were demolished during World War II. (Courtesy Goodspeed Corpe.)

THE KELLMAN HOUSE. The Kellman House, pictured in 1967, is framed entirely in redwood. The original owner, Mrs. Grace Kellman, used it as a weekend cabin. Though built between 1938 and 1939, the aluminum roof appears brand new today. Kirk and Gail Reid purchased the home in 1967 and renamed it Fort Reid. (Courtesy Reid.)

THE WRIGHT RANCH HOUSE. Built in 1910 on a gentle knoll overlooking a small lake, the house sits on the San Andreas earthquake fault. Why would Sumner Wright do such a thing? Because that is where the source of water was. Ruth Pfefferle mentioned in an early narrative, "A small stream ran directly under the house; we kept milk and eggs in it to keep cool." The home has been owned by John Cromshow since 1986.

SKYDORE. An old, tattered and patched dwelling, it has an interesting history. "Situated high above Helen St. , / I always thought its name so neat. / The house decrepit from ceiling to floor, But bore the majestic name of 'Skydore.' / An alliteration of the owner's name, / Who had some psychic claim to fame. / To numerous séances / Aldous Huxley came." (Courtesy Moore.)

64

GREETINGS FROM SKYDORE. The twin photos on this postcard show disciples of Kay Mullendore cavorting in the woods.

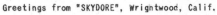
Greetings from "SKYDORE", Wrightwood, Calif.

THE FIRE STATION. This 1948 photo shows the original building. Judge Nix donated the land, Wrightwood Lumber erected the building at cost, and all the labor was donated.

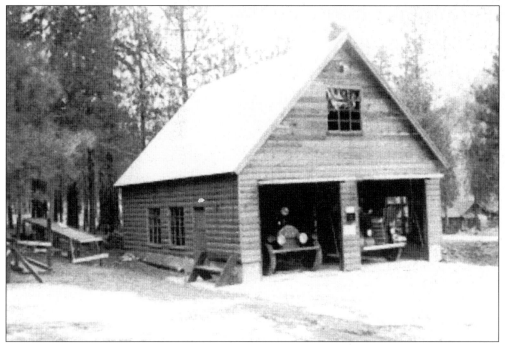

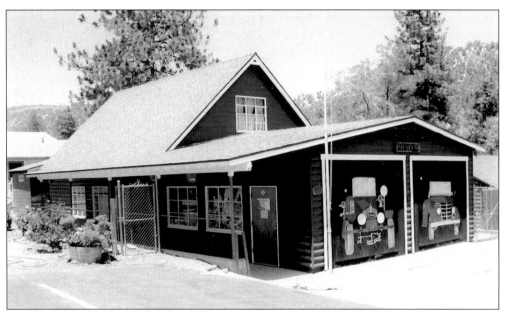

THE OLD FIREHOUSE MUSEUM. A new fire station was built in 1978 on Highway 2, and the old building was abandoned. Francis Yarnall, president of the Wrightwood Historical Society, saw it as a perfect museum, and the old structure was repaired.

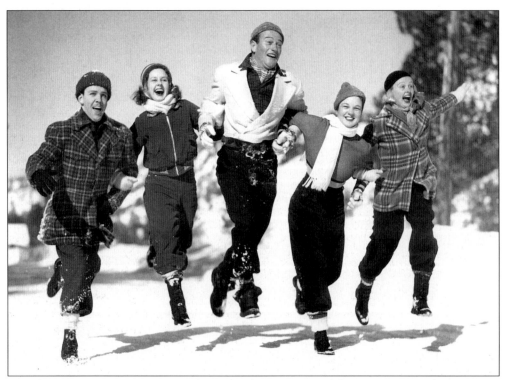

THE DUKE VISITS WRIGHTWOOD. Actor John Wayne and his movie crew shot a movie here in 1935. The town was agog when the trucks and crew arrived on location. (Courtesy Universal Studios.)

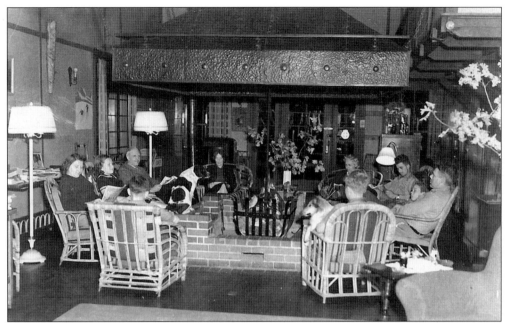

LOBBY OF WRIGHTWOOD LODGE, C. 1939. The comfortable lobby of the lodge, with the beautiful fireplace in the center, welcomed all who stopped by. This was an old mountain hotel with only 20 rooms. Four baths connected eight rooms, while the remaining accommodations were served by a restroom and bath "down the hall," lit by a 40-watt bulb dangling from a frayed cord. Each room had a metal bedstead, wood painted armoire, a wash basin with mirror above, one small window, and an un-vented propane heater. (Courtesy Goodspeed Corpe.)

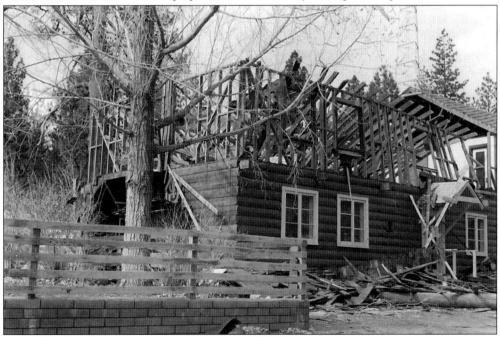

THE END OF AN ERA. After 40 years, the Wrightwood Lodge was torn down in 1964. The site is now home to the community center. (Courtesy Goodspeed Corpe)

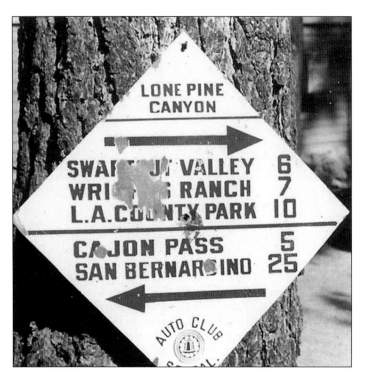

AUTO CLUB SIGNS. These 1929 road signs directed travelers to such spots as Lone Pine Canyon, Wright's Ranch, and Big Pines.

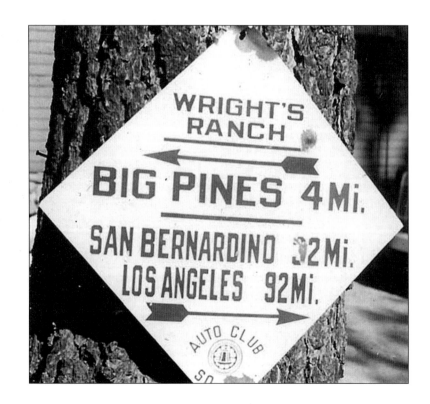

Six

GOOD TIMES
AT BIG PINES

Big Pines is located four miles west of Wrightwood in the Angeles National Forest. This popular recreation area was developed in the early 1920s by the Los Angeles County Board of Supervisors and the Department of Parks and Recreation. Chairman of the Board R.F. McClellan wanted the people of Los Angeles to have a place where they could enjoy the outdoors without restraints such as fences, private roads, and billboards. In 1923 the board purchased 760 acres of privately owned land at Big Pines. Work began immediately on what would become known as Big Pines Park or Big Pines Camp. Under the direction of the Department of Parks and Recreation, a large work force of county employees and convict labor quickly built the park. The early construction included the Recreation Hall, also referred to as the clubhouse, and a central campground on a hillside opposite the Hall. The park was opened on Labor Day, 1924.

Construction continued in preparation for the first winter season at the park. Slopes and runs for tobogganing and sledding were cleared and work began on the lodge facility adjacent to the Recreation Hall. As the expansion of the park continued, Big Pines became a year-round playground with crowds up to 10,000 on many weekends. The facilities were well run, the activities were well organized, and Big Pines Park gained the reputation as an outstanding mountain resort.

WINTER FUN. Tobogganing was a favorite activity at Big Pines. (Courtesy Huntington Library, San Marino, California.)

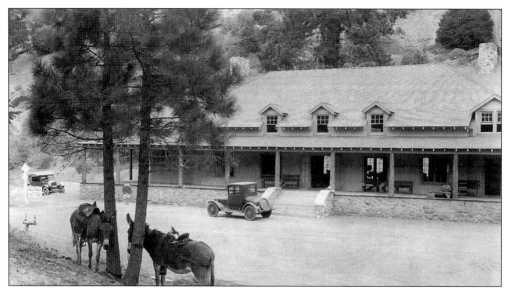

RECREATION HALL. Built in 1924, the hall still stands today. This magnificent building had a spacious dance floor, a stage, two large fireplaces, a library and reading room, a first-aid room with seven cots, administrative offices, and two upstairs apartments. (Courtesy Rich McCutchan.)

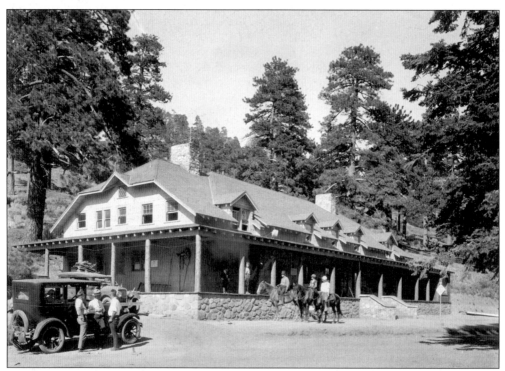

SOUTHWEST CORNER, RECREATION HALL. The Recreation Hall was constructed of native rock and timber taken from the park. The building was designed to become the center of all community and indoor recreational activities. (Courtesy Huntington Library, San Marino, California.)

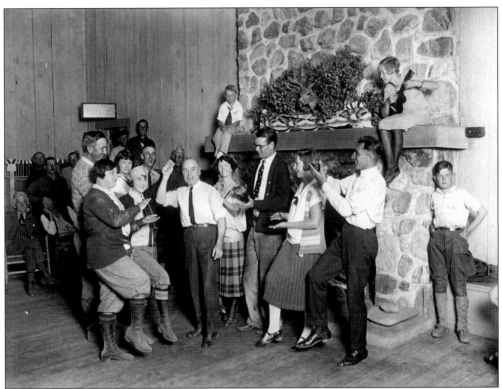

INSIDE THE HALL. Many summer and winter activities were held in the Recreation Hall. This photo depicts a small group doing a folk dance. Most old-timers remember the wonderful Saturday night dances with live music provided by local bands. (Courtesy Los Angeles Public Library.)

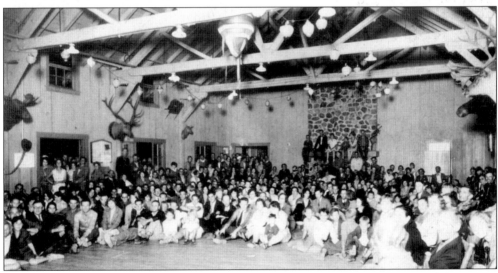

PROGRAM TIME. The large hall accommodated many people who wanted to attend the variety of programs that were offered, including talent shows, plays, talks, movies, and games. Some folks preferred to just sit and read a good book from the library provided by the county. (Courtesy Rich McCutchan.)

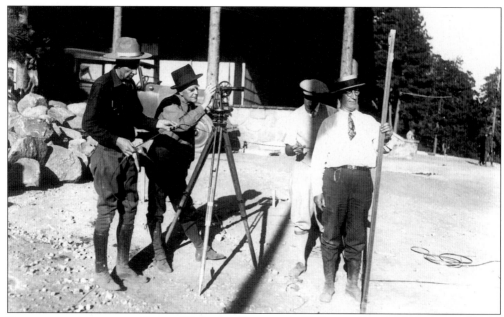

PREPARATION FOR THE ARCH. With the Recreation Hall completed, another project was undertaken—the entrance arch. Park Superintendent Fred Wadsworth, Supervisor R.F. McClellan, Superintendent of Construction C.J. Herbold, and Chief Mechanical Engineer William Davidson are shown surveying for the new arch. (Courtesy Los Angeles Public Library.)

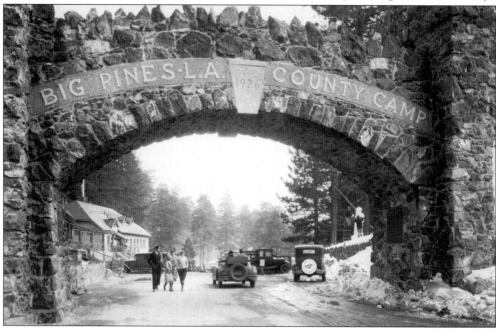

COMPLETED ARCH. The arch was designed and erected by William Davidson and his associates, who donated it to Los Angeles County. The arch served as a pedestrian crossing over the park highway. Inside the north tower was a stairway leading to an arched doorway that opened onto the arch. The first floor contained a barred cell originally used to temporarily confine troublesome park visitors until the sheriff arrived. (Courtesy Huntington Library, San Marino, California.)

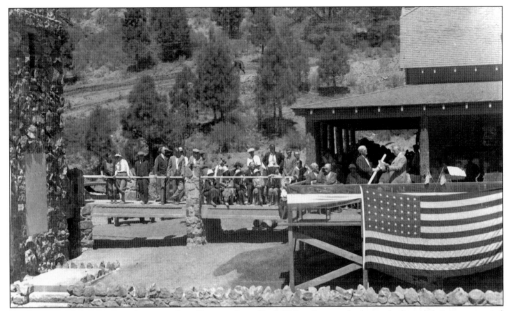

DEDICATION OF THE ARCH. On September 5, 1926, the arch was dedicated in a special ceremony. Aside from providing an overpass for pedestrians from the north side of the highway to the camping areas on the Blue Ridge side, the arch was a favorite spot for children to play or to just cool off on the smooth cement steps. (Courtesy Los Angeles Public Library.)

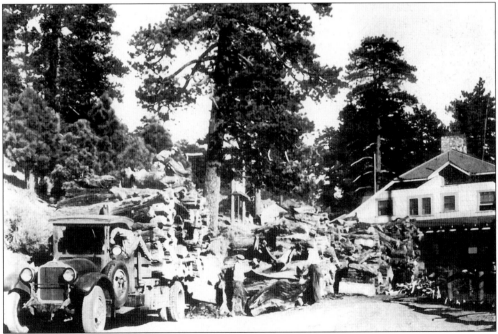

GETTING READY FOR WINTER. The two massive stone fireplaces in the Recreation Hall consumed many cords of firewood. The park had become so successful that immediate plans for expansion were required. In 1925 the Forest Service granted a special-use permit for an additional 3,560 acres, extending westward from Big Pines to Mescal Canyon and southward to include Prairie Fork Canyon. (Courtesy Christine Lange.)

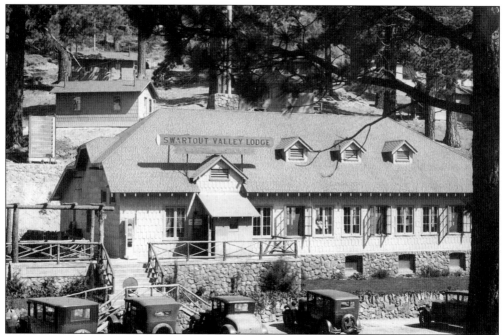

THE LODGE. In 1925–1926, the lodge was completed. Over the years, it housed a store, restaurant, soda fountain, and a post office. There were also 14 rustic rental cabins available, which offered an alternative to camping. The cabin rate, including meals, was $5 per person per day. (Courtesy Huntington Library, San Marino, California.)

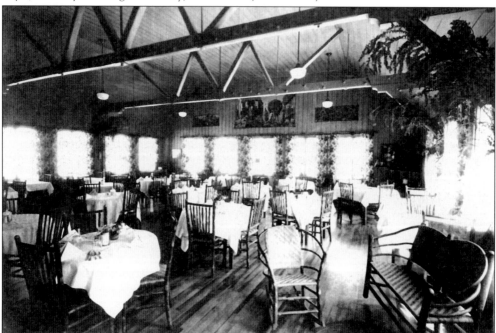

DINING ROOM. The dining room in the lodge was reminiscent of Yellowstone or Yosemite. Advertised as "The beauty spot of the Southland," the dining room promised "always a fine meal." (Courtesy Frasher Fotos, Pomona Public Library.)

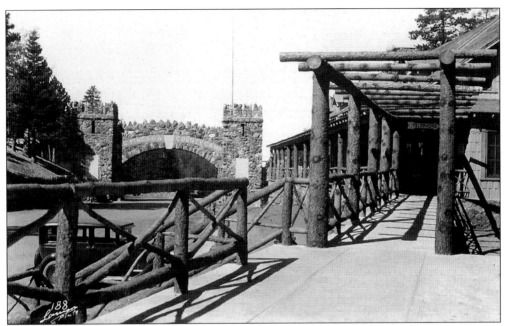

CHARMING WALKWAY. Connecting the lodge and the recreation hall was a picturesque walkway constructed from unpeeled tree trunks and smaller unpeeled limbs. The veranda in front of the hall was a popular gathering place. (Courtesy Rich McCutchan.)

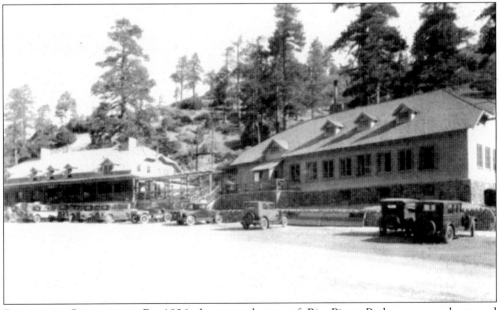

BUILDINGS COMPLETED. By 1926 the central area of Big Pines Park was complete, and construction continued at other sections of the park. The beautiful stonework on and around the buildings was done by Ollie Dahl and Robert Sayle, supplemented with convict labor. In between the buildings was a small reflecting pond and the stairway leading up the hill to the cabins. (Courtesy Frasher Fotos, Pomona Public Library.)

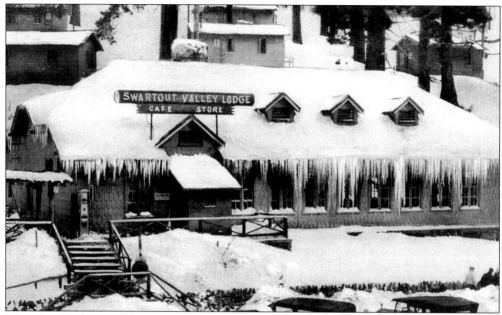

WINTER AT THE LODGE. The lodge became known as the Swartout Valley Lodge. It was named for Nathan and Truman Swarthout, early settlers in the Wrightwood area. A post office was established in October 1926, two years before Wrightwood had one. The name was misspelled by the Post Office Department. (Courtesy Rich McCutchan.)

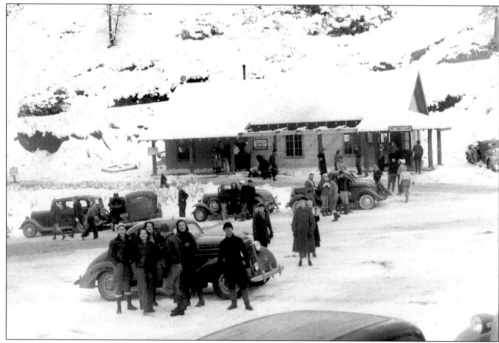

SPORTS PAVILION. Another building, known as the Sports Pavilion, was situated just west of the recreation hall. Here visitors could rent skates, skis, toboggans, and sleds. There was also a hot dog stand located here. (Courtesy Huntington Library, San Marino, California.)

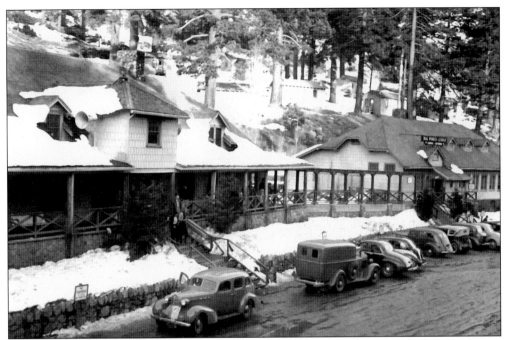

BIG PINES, C. 1936. The sign on the lodge now says, "Big Pines Lodge," replacing the Swartout Valley Lodge sign. Around 1936 the Quigley family took over the lease for the lodge and the store. This photo also shows the projection booth that was built so movies could be shown in the recreation hall. (Courtesy Jody Lopez.)

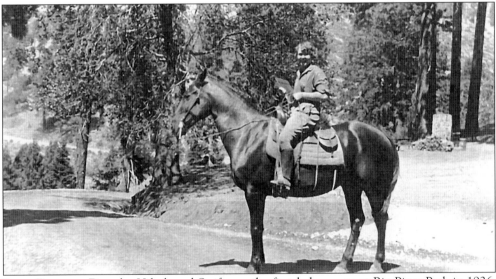

LADY RANGER. Dorothy Hiltabrand Swift was the first lady ranger at Big Pines Park in 1926. Her job was to patrol the canyons around Table Mountain, check the restrooms in the park, take campers on nature hikes and trail rides, and serve as a lifeguard at the pool. This photo was taken on Blue Ridge Road with one of the camp sites in the background. (Courtesy Dorothy Hiltabrand Swift Collection, Wrightwood Historical Society.)

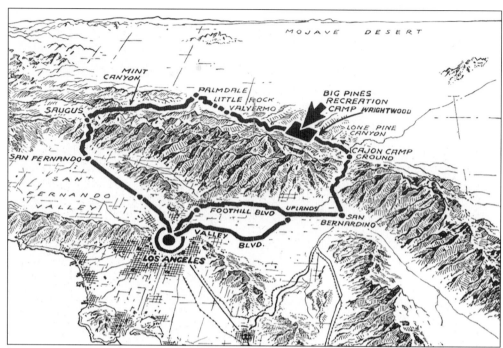

ROUTES TO BIG PINES. Early maps gave directions from Los Angeles to Big Pines via San Bernardino or Saugus. The distance was 96 miles via San Bernardino and 106 miles via Saugus. (Courtesy Rich McCutchan.)

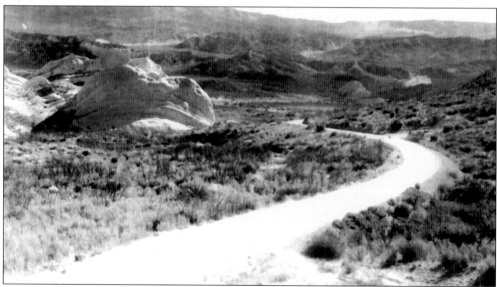

LONE PINE CANYON. Until 1937 Lone Pine Canyon was the only way to reach Big Pines from Los Angeles via San Bernardino. Halfway up the canyon was a water trough where cars could stop and fill up their radiators. A motor stage ran from San Bernardino to Big Pines on a daily schedule. (Courtesy Frasher Fotos, Pomona Public Library.)

BIG PINES LODGE

THE BEAUTY SPOT OF THE SOUTHLAND
Two Hours Drive from Los Angeles over a high-gear
Highway open all year
HEADQUARTERS FOR ALL SNOW SPORTS

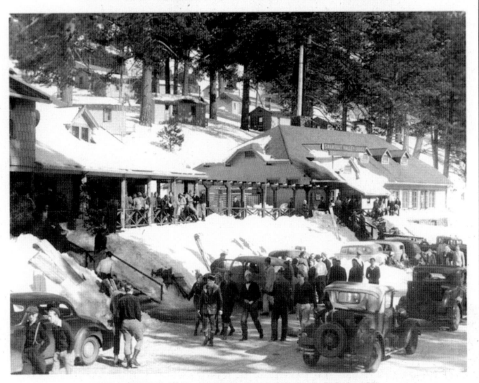

THE LODGE AND CABINS AMONG THE BIG PINES

AT THE SPORTS PAVILION
You can rent Skates, Skiis, Toboggans, Sleds, Etc. Refreshments Served Daily

AT THE LODGE DINING ROOM
Always a Fine Meal

EUROPEAN PLAN $2.00 PER DAY - AMERICAN PLAN $5.00 PER DAY - NO
HOUSEKEEPING CABINS . WEEK ENDS AMERICAN PLAN ONLY
DANCING SATURDAY EVENINGS

Make Your Reservations Early with
W. S. QUIGLEY, Manager, Swartout, California, or through the Auto Club of Southern California, 2601 So. Figueroa St., Los Angeles - Phone RIchmond 3111.

ADVERTISEMENT FOR THE LODGE. This was the place to be! (From *Trails Magazine*, Autumn, 1938; courtesy Barbara Van Houten.)

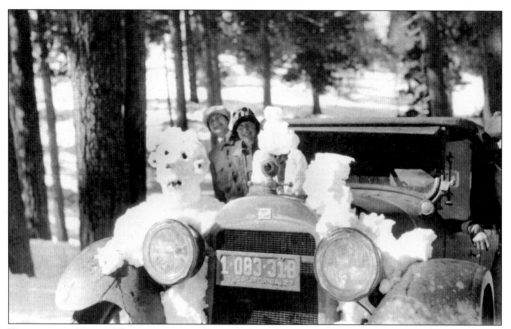

FUN IN THE SNOW. These visitors to the park found an interesting use of the snow. The license plate says 1927. (Courtesy Frasher Fotos, Pomona Public Library.)

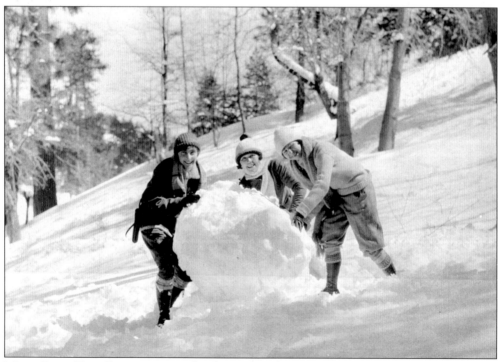

MORE SNOW FUN. Everyone seemed to have a good time at Big Pines. (Courtesy Huntington Library, San Marino, California.)

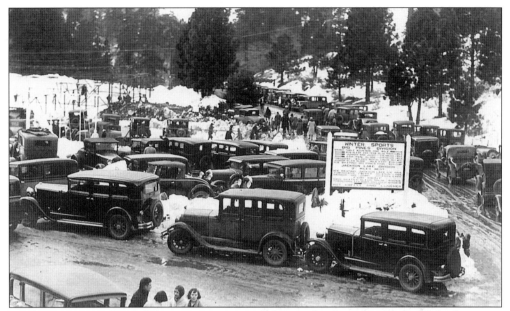

NO SHORTAGE OF CARS. Winter sports attracted thousands of visitors as soon as the first snow fell. A variety of activities was available, both at Big Pines and at Jackson Lake, located three miles west of Big Pines. This photo shows the junction at Big Pines Highway, just west of the Arch, and the Blue Ridge road. (Courtesy Rich McCutchan.)

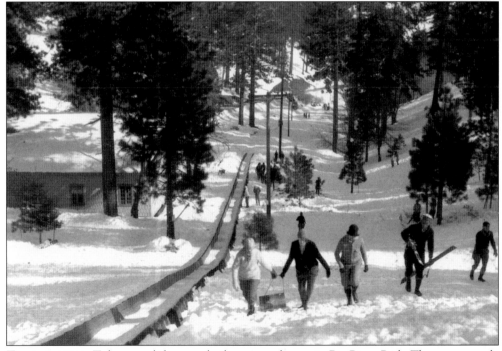

TOBOGGANING. Toboggan slides were built at several areas in Big Pines Park. These were made of U-shaped sheet iron on wooden frames, each section about eight feet long. The sections were joined to make a slide about 200 feet long. The slides were placed on fairly steep slopes, with a good run-out at the end. (Courtesy University of Southern California, Archival Collections.)

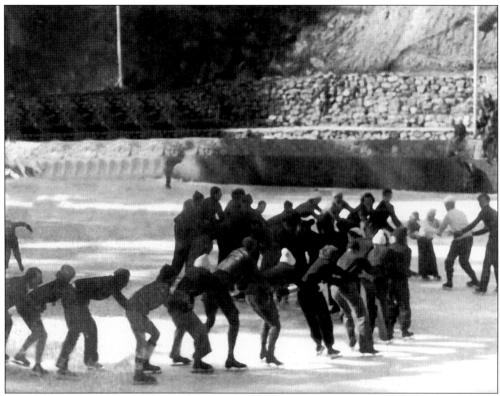

ICE SKATING. In 1933 the ice rink was built just six-tenths of a mile down the county road west of the arch. Thousands of visitors enjoyed skating at the outdoor rink every winter. "Crack-the-Whip" was a popular skating activity. (Courtesy U.S. Forest Service.)

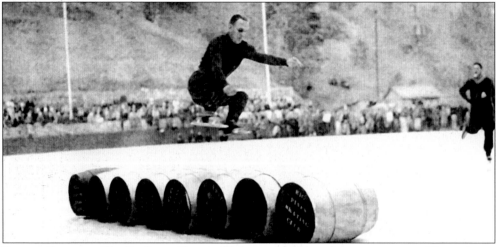

BARREL JUMPING. The Big Pines Skating Club sponsored barrel-jumping events. The rink was maintained by one of the rangers, Leonard "Red" Luglan, who "missed many meals and a lot of sleep in order to give the skate-pushers just the right kind of ice." The rink provided "better facilities and the most consistent skating of any of the Southern California resorts," according to *Trails Magazine* in 1937. (Courtesy Los Angeles Public Library.)

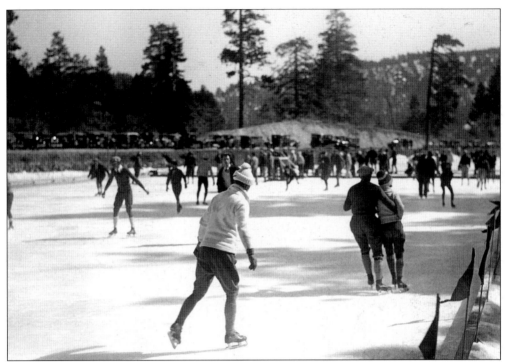

JACKSON LAKE. Ice skating also took place at Jackson Lake. In the early years the ice froze deep enough to accommodate skaters. (Courtesy Huntington Library, San Marino, California.)

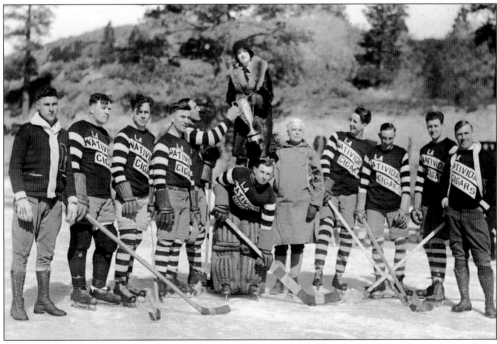

ICE HOCKEY. Another popular winter sport was ice hockey. Pictured in the middle of the photograph is R.F. McClellan, Los Angeles County supervisor, and an unidentified young lady presenting a trophy to the hockey team. (Courtesy Huntington Library, San Marino, California.)

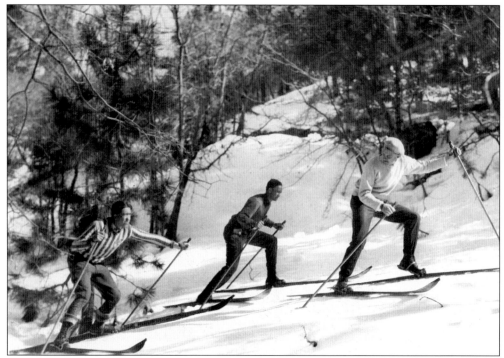

SKI TOURING. In 1935 construction was finished on five miles of trails designed for ski touring. The trails, which were cleared by the Civilian Conservation Corps, helped make ski touring an exciting winter activity. (Courtesy Huntington Library, San Marino, California.)

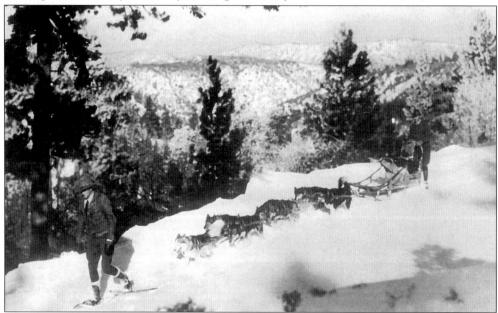

DOG TEAMS. Snowshoes and dog teams were used for recreation, for hauling supplies and for search and rescue operations. This photo from 1933 shows sled dogs owned by O.P. Doan, a Ranger at Big Pines Park. Doan can be seen at the back of the sled; at the front of the team is Slim Cowie, a ranger naturalist. (Courtesy Rich McCutchan.)

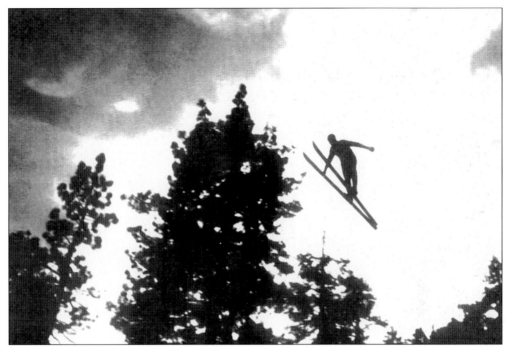

SKI JUMPING. One of the most exciting winter activities at Big Pines was the sport of ski jumping. In 1929 a world-class ski jump structure was built in time for the Third Annual Winter Sports Carnival. Several world record-breaking jumps were made at Big Pines. (Courtesy University of Southern California, Archival Collections.)

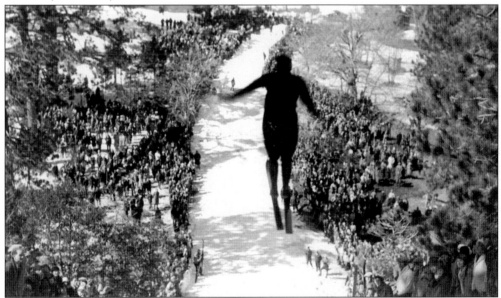

NEW JUMP HILL. In 1931 a new ski jump was built at Big Pines and was declared to be the world's longest. People came to Big Pines just to watch the jumpers, many of whom were from other countries. In 1939, 25,000 people entered Big Pines Park in just one weekend for the Winter Sports Carnival. It was at this event that the all-time distance record for the Big Pines hill was broken with a leap of 265 feet. (Courtesy University of Southern California, Archival Collections.)

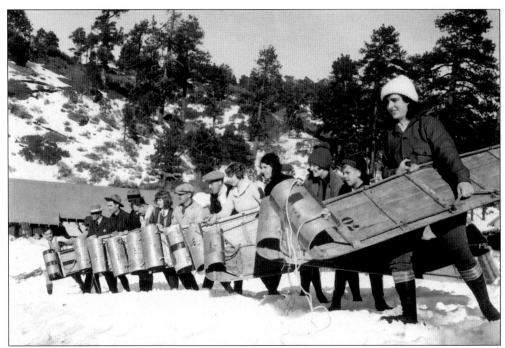

GROUP TOBOGGANING. The beginning of the toboggan run at the 1934 Winter Sports Carnival is captured in this photo. (Courtesy Los Angeles Public Library.)

BABY TOBOGGANIST. There was no age limit for tobogganists at Big Pines Park. (Courtesy Los Angeles Public Library.)

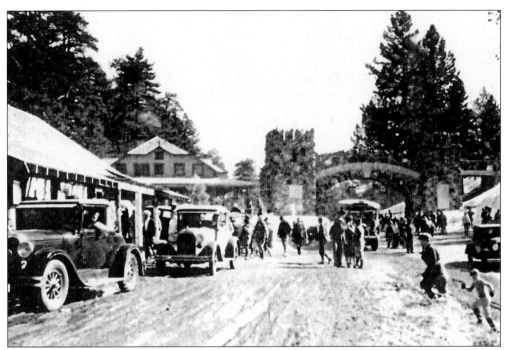

WINTER CROWD. The building in the foreground was the Sports Pavilion and Hot Dog Stand, which was a popular attraction on a cold day. (Courtesy Los Angeles Public Library.)

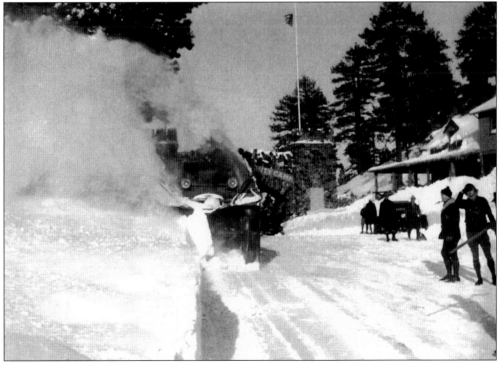

SNOW PLOWS. Snow storms didn't stop visitors from coming to Big Pines. The county had snow plows ready to keep the roads open every day. (Courtesy Ann Dormer Johnson.)

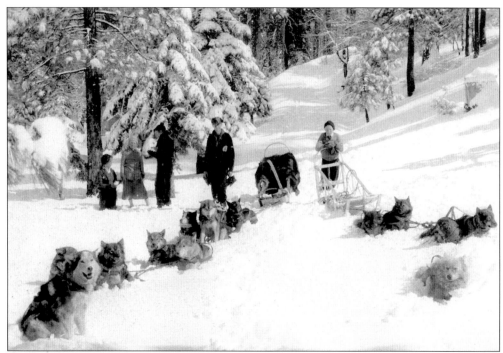

SLED DOGS. Ranger O.P. Doan and his son Paul are shown resting their sled dogs in 1932. Mrs. Kathleen Doan is in the background talking to some visitors. The Doan family lived in a tent house just west of the meadow from 1929 to 1935. (Courtesy Walt Doan.)

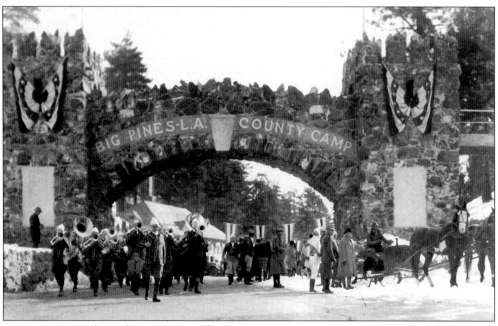

OPENING DAY. The arch was always a focal point for activities. This photo shows the opening day of the 1929 winter season. The man in the long coat standing next to the sleigh is R.F. McClellan, Los Angeles County supervisor . (Courtesy Christine Lange.)

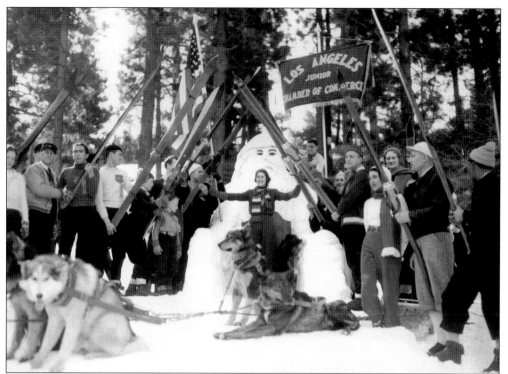

WINTER CARNIVAL. Beginning in 1927 the Los Angeles Junior Chamber of Commerce began sponsoring the annual Winter Sports Carnival at Big Pines. The opening ceremonies included crowning the Snow Queen. O.P. Doan's sled dogs are shown, along with his two young sons Paul and Phil, standing to the side of the snow throne. (Courtesy Los Angeles Public Library.)

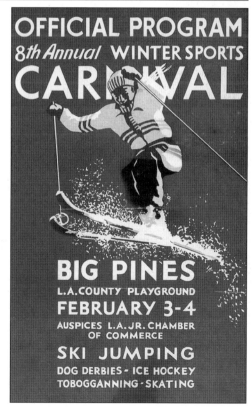

1934 CARNIVAL. The official program listed a variety of events such as barrel jumping, intercollegiate ice hockey games (USC *vs.* UCLA), homemade snow shoe race, fancy skating exhibitions, and the college pentathlon, which included ski jumping, cross-country skiing, and slalom race. The Western America Amateur Ski Jumping Championship was also held. At the end of the day, dances were held at both Big Pines and Wrightwood. (Courtesy Rich McCutchan.)

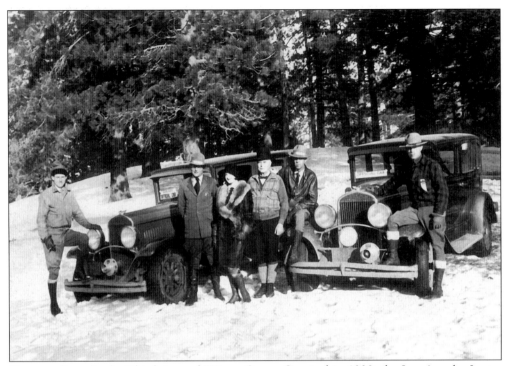

OLYMPIC BID. At the Third Annual Winter Sports Carnival in 1929, the Los Angeles Junior Chamber of Commerce attempted to win the bid for the 1932 Winter Olympics. Los Angeles had already been awarded the 1932 Summer Games, and it seemed logical that the Winter Games should be held at Big Pines Park, hosted by Los Angeles. Since the Olympic selection committee was slated to attend the winter carnival, much time was spent preparing Big Pines for the weekend event. The 1,150-foot-long master ski jump was completed, and the ice hockey game was the first ever played in the out-of-doors in Southern California. More than 19,000 people attended the event, which was held for three days. In spite of the highly successful winter carnival, the Olympic selection committee did not choose Big Pines, but selected Lake Placid, New York, instead. A protest was filed but to no avail. Shown are Los Angeles County officials at the 1929 event, including Supervisor R.F. McClellan, wearing a plaid jacket and top hat. (Courtesy Christine Lange.)

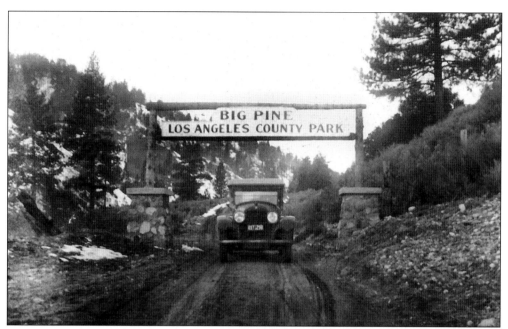

EAST ENTRANCE. This shows the eastern entrance to Big Pines Park, near what would later become Holiday Hill Ski Area, now Mountain High East. This early sign referred to the area as "Big Pine." (Courtesy Department of Special Collections, Charles E. Young Research Library, UCLA.)

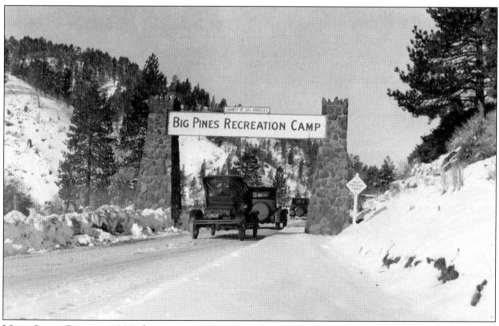

NEW SIGN. Prior to 1927 the entrance sign was changed to "Big Pines," and the wooden posts were replaced with stone pillars. (Courtesy Frasher Fotos, Pomona Public Library.)

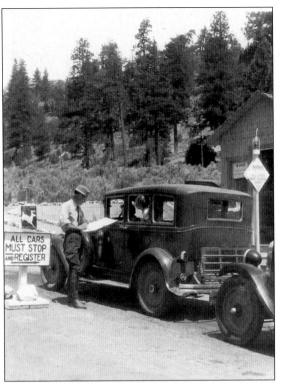

CHECK STATION. Just inside the eastern entrance was a check station, known as East Gate, where visitors had to stop and register. A ranger was on duty during daylight hours. Visitors had to leave their name and car license number. Wood was sold for 50¢ a bundle. A similar check station was located at the west end of the park, near Jackson Lake. (Courtesy U.S. Forest Service.)

CAMPING. The campgrounds were very popular during the summer months. Campsites included stone fireplaces for cooking, picnic tables, fire pits for evening bonfires, piped water, and comfort stations. Sections of the campground were electrically lighted. (Courtesy University of Southern California, Archival Collections.)

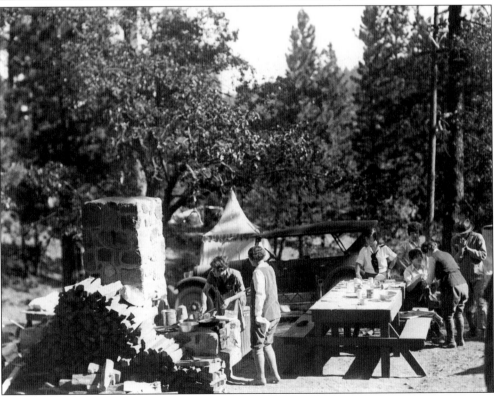

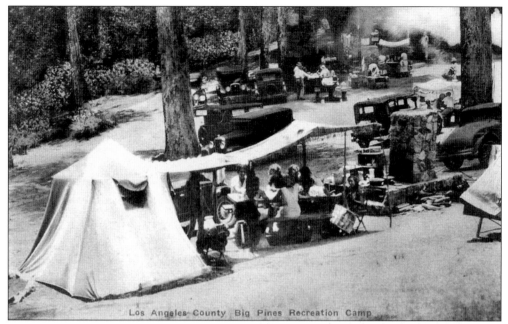

Los Angeles County Big Pines Recreation Camp

SUMMER FUN. Many families spent several weeks in the campgrounds. Some stayed all summer. As soon as school was out in June there was a mass exodus to Big Pines. Tents were pitched, housekeeping was set up, and the campers were ready for summer fun. (Courtesy Rich McCutchan.)

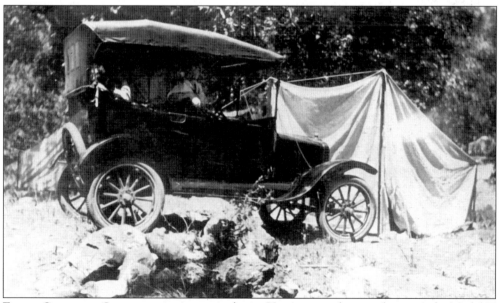

EARLY CAMPSITE. Some camping gear was basic. Here we see the proud owner of a Model-T Ford and his tent. Summer temperatures were quite pleasant at Big Pines, where the elevation is 6,862 feet. (Courtesy Barbara Van Houten.)

THE ERNEST FAMILY. Shown in this *c.* 1925 photo, from left to right, are Charles, Juanita, Pearl, Aleta, and Eugene Ernest. (Courtesy Barbara Van Houten.)

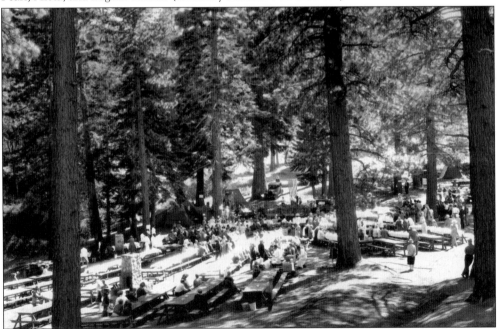

A BUSY CAMPGROUND. Festivals and parties were often held in the campgrounds. County park personnel provided summer recreation programs that easily rivaled the winter activities. Regularly scheduled events included nature walks, handicraft classes, canoeing lessons, swimming classes, carnivals, and programs at the amphitheater, which was located at the east side of the Big Pines campground. (Courtesy University of Southern California, Archival Collections.)

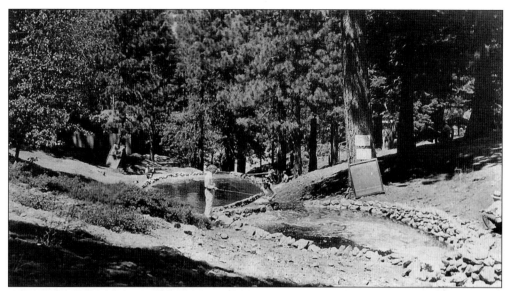

FISH POOLS. Along Blue Ridge Road, southwest of Big Pines Campground, were several small fish pools stocked with trout for the campers' pleasure. A small stream tumbled down through the rocks, providing water for the pools. (Courtesy Rich McCutchan.)

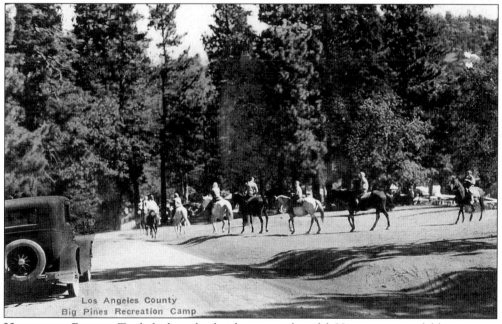

Los Angeles County
Big Pines Recreation Camp

HORSEBACK RIDING. Trails for horseback riding were plentiful. Horses were available to rent at a cost of $4 per day. Other summer activities included hiking, mountain climbing, fishing, and swimming at either Jackson Lake or at the large swimming pool west of the arch. A softball field was located to the west of the pool. (Courtesy Rich McCutchan.)

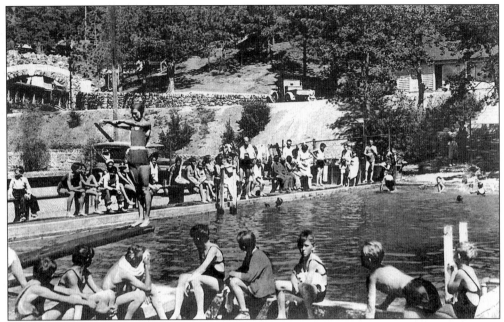

SWIMMING POOL. Known as the Big Pines Plunge, the pool was within walking distance from the arch, just west of the road going up to Blue Ridge. Built in 1927, the pool was closed in 1938 due to a leak. It was filled with soil in 1939. (Courtesy Rich McCutchan.)

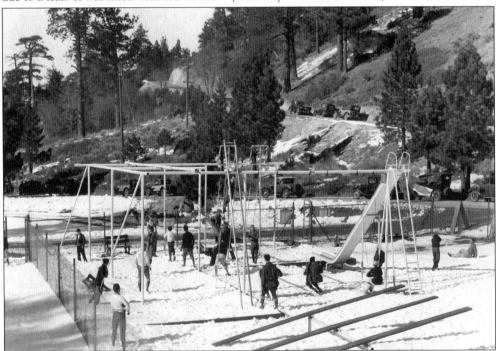

PLAYGROUND. The children's playground was located in the same area as the pool. Between the playground and the pool was a court suitable for volleyball and other games. Shown is the upper road going to Table Mountain and the lower road going to Jackson Lake. (Courtesy University of Southern California, Archival Collections.)

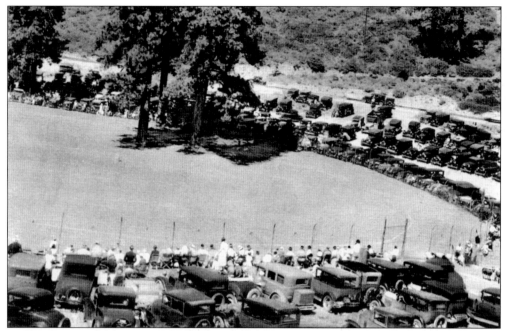

RODEO GROUNDS. At the end of the summer season, usually on Labor Day Weekend, a rodeo would be held. The location, east of Big Pines, would later become the parking lot for Holiday Hill Ski Area, now Mountain High East. (Courtesy Rich McCutchan.)

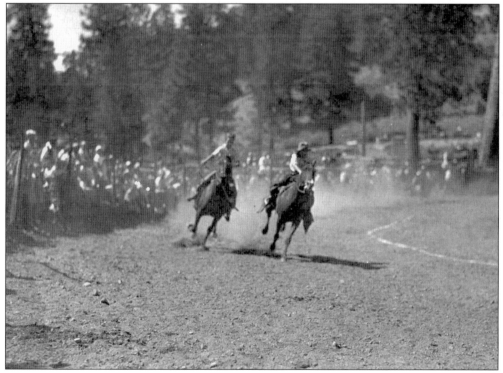

RODEO RIDERS. Two young cowboys compete in the rodeo. Paul Doan is the rider wearing the cowboy hat. (Courtesy Walt Doan.)

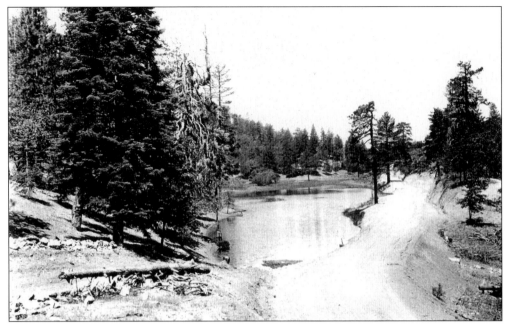

JACKSON LAKE. In the early years, the area known as Jackson Lake was a spring-fed pond and a small creek. According to Harvey R. Cheesman, U.S. Forest Service ranger, settlers from the Llano Socialist Colony built a dam across Mescal Creek in the summer of 1914. The settlers had hoped to use the enlarged lake as a water source, but the colony failed, and Jackson Lake became available for use as a recreational facility. (Courtesy Frasher Fotos, Pomona Public Library.)

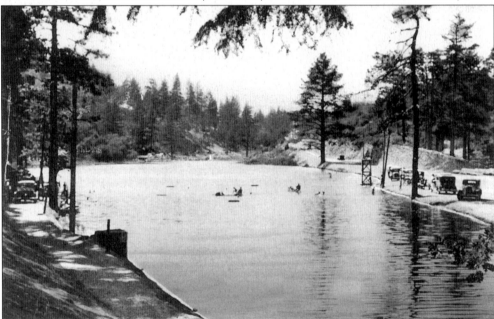

THE LAKE EXPANDS. The lake increased in size over the years. Los Angeles County improved the beaches and raised the level of Jackson Lake. They also built a twelve-mile road from Valyermo to Big Pines that ran past the lake. The new road allowed easier access to the Big Pines area from the Antelope Valley. (Courtesy Rich McCutchan.)

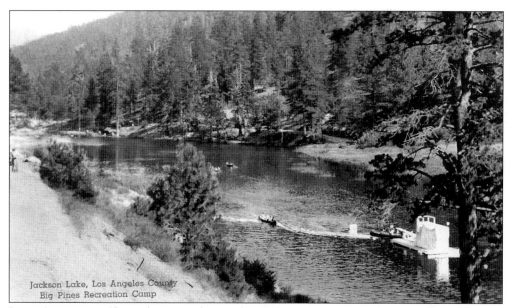

Jackson Lake, Los Angeles County
Big Pines Recreation Camp

LAKE ACTIVITIES. Shown here is Jackson Lake in 1925. Notice how it has changed from earlier pictures. Swimming and boating were the major activities. Fishing later became very popular. (Courtesy Rich McCutchan Collection.)

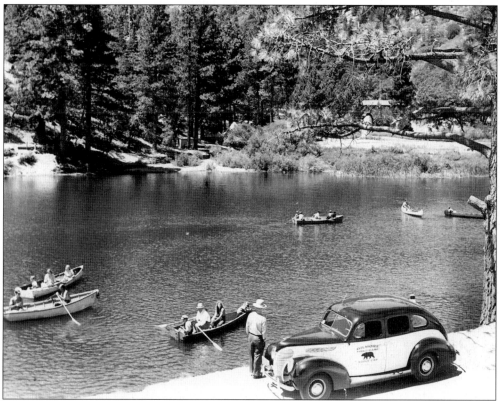

CHECKING THE FISHING. Canoeing was a favorite activity at Jackson Lake. The sign on the car reads "Gilmore Fish and Game Scout Car." (Courtesy Wrightwood Historical Society.)

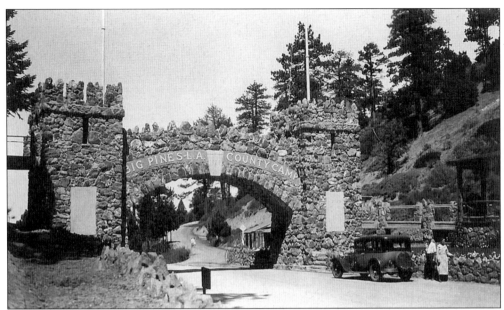

TABLE MOUNTAIN ROAD. A rough road was built in 1918 to give access to a lumber mill on Table Mountain. In 1925 an improved road was built up to Table Mountain for the Smithsonian Observatory, which is now operated by Jet Propulsion Laboratory. The road winding up to Table Mountain can be seen through the arch. (Courtesy Rich McCutchan.)

A CHALLENGING DAY. Shown in this photo is Preston Butler, director of the Smithsonian Observatory from 1939 to 1941, on Table Mountain Road just past Mc Clellan Flat. This was a difficult road in the winter. (Courtesy Butler family.)

McClellan Flat. Located on Table Mountain Road is McClellan Flat, originally known as Camp McClellan, built in the 1920s. This area consisted of 13 cabins owned by members of the L.A. County Board of Supervisors, the park superintendent, chief engineer, and chief ranger. The cabins are currently privately owned under special-use permits from the U.S. Forest Service. This is a photo of Cabin Eight. (Courtesy University of Southern California, Archival Collections.)

Scenic View. Park Superintendent Fred Wadsworth is shown in this 1925 photograph pointing out the scenic view south from Inspiration Point toward the San Gabriel Valley. (Courtesy Los Angeles Public Library.)

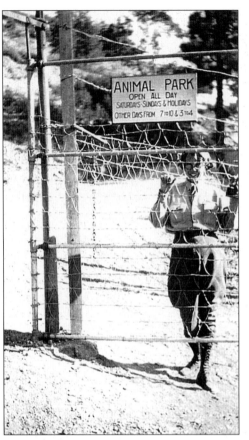

ANIMAL PARK. In the early 1920s a small animal park was maintained for the enjoyment of park visitors. It was located about one-fourth mile up Table Mountain Road from the arch. Shown in the photo is Jo Plummer, secretary at the Big Pines Office. (Courtesy Dorothy Hiltabrand Swift Collection, Wrightwood Historical Society.)

THE BUFFALO. The animal park was the home of buffalo, elk, deer, bear, reindeer, and smaller animals. Several structures were built at the park, including a barn where horses were kept and where, from 1929 to 1935, Ranger O.P. Doan kept his 16 sled dogs. (Courtesy Dorothy Hiltabrand Swift Collection, Wrightwood Historical Society.)

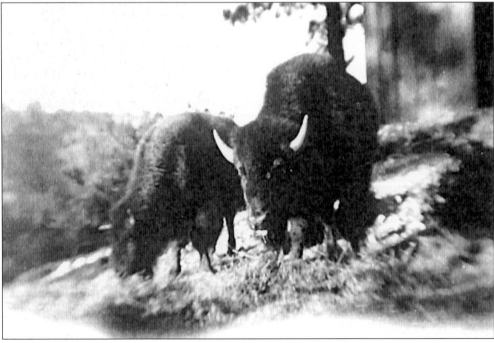

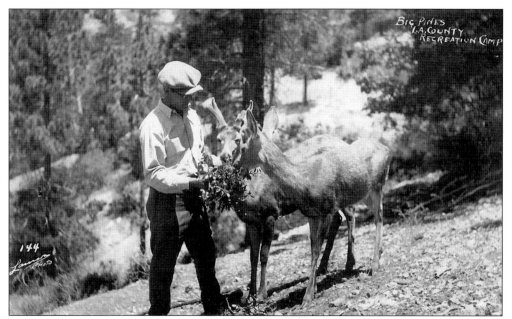

FEEDING THE ANIMALS. Forest visitors enjoyed visiting the animal park because it was both entertaining and educational. (Courtesy Rich McCutchan.)

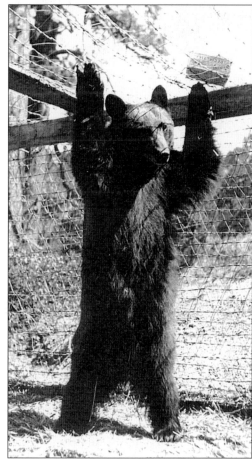

BROWNIE THE BEAR. Maintaining the animal park required a lot of work. Honor Farm crew members helped with the maintenance. When the park closed in the early 1930s, the animals were moved to other zoos. (Courtesy Dorothy Hiltabrand Swift Collection, Wrightwood Historical Society.)

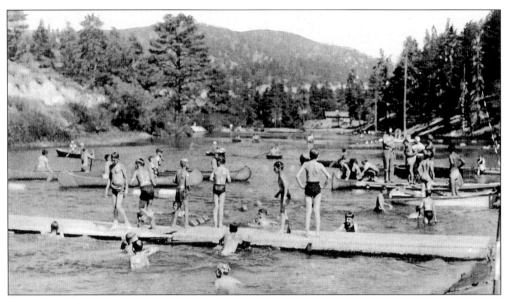

ORGANIZATION CAMPS. By the mid-1930s the county had under construction or had completed 14 camps to be occupied by various organizations, such as Boy Scouts, Girl Scouts, Camp Fire Girls, and church groups. These campers were often found enjoying Jackson Lake. (Courtesy Rich McCutchan.)

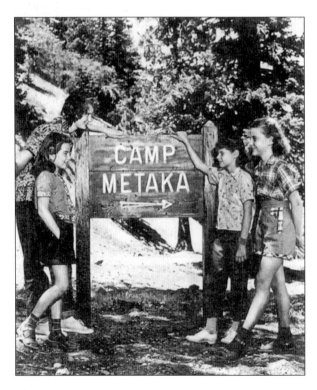

CAMP METAKA. Camp Metaka, one of the early organization camps, was operated by the Rio Hondo Council of the Camp Fire Girls. (Courtesy Rich McCutchan.)

CAMP MCKIWANIS. Operated by the McKinley Home for Boys and sponsored by the Kiwanis Club, this was a primitive camp with outdoor sleeping areas, just east of Camp Hemohme. In later years Camp McKiwanis moved across the street to an improved camp and operated there until 1961, when the City of Commerce bought the camp. Shown are Frank, Lillian, and Joan Trapani seated at the long table on the right. (Courtesy Dan and Joan Burns.)

ENJOYING JACKSON LAKE. Pictured, from left to right, are Lillian, Joan, Frank, and Chuck Trapani (seated). Frank was the director of Camp McKiwanis from 1940 to 1960. Joan married Dan Burns, who built a privately owned public swimming pool in Wrightwood. (Courtesy Dan and Joan Burns.)

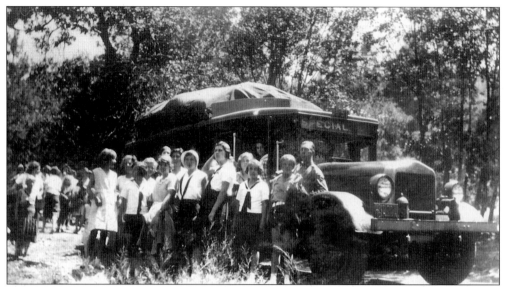

CAMP TERESITA PINES. Originally operated by the Catholic Daughters of America, Teresita Pines is one of the oldest and possibly the best-preserved camp in the area. In 1995 the camp was purchased by the Lions' Club and is now known as Lions' Camp at Teresita Pines. Campers are seen arriving in 1932. (Courtesy Mary Anne Aarset, Teresita Pines.)

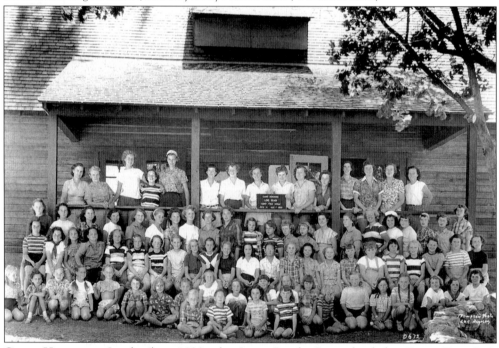

CAMP HEMOHME. In the late 1930s the Long Beach Council of the Camp Fire Girls established Camp Hemohme. The camp has changed hands several times over the years, but many of the original structures are still being used. This photo was taken on the porch of the main lodge in 1950. Currently the camp is known as Wrightwood Camp and Conference Center, operated by the Episcopal Diocese of Los Angeles. (Courtesy Mitch and Bonnie Jones, Camp Hemohme Collection.)

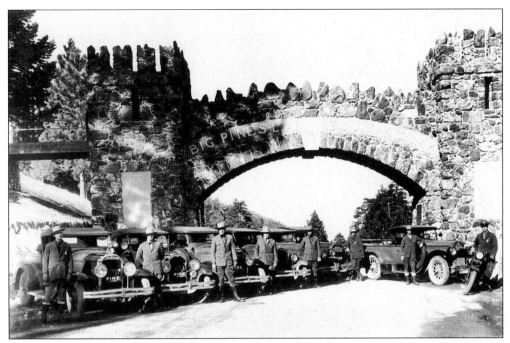

COUNTY RANGERS. This mid-1920s photo shows the personnel of the County Ranger Department. Several of the trucks have plates that say "Fire Warden." The county had very strict fire rules for the Big Pines Area. (Courtesy Christine Lange.)

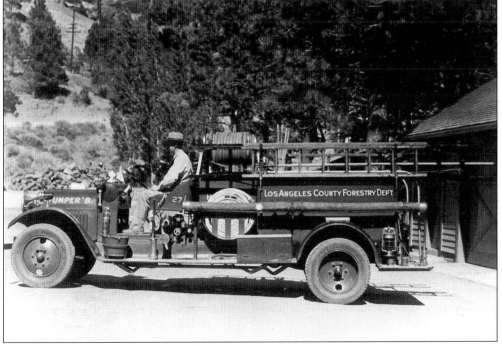

OLD FIRE TRUCK. Fire prevention was an important program of the county. Assistant Chief Ranger Harlow Dormer sits at the wheel of the county fire truck, Pumper "B," parked in front of the fire hut on the road to Blue Ridge. (Courtesy Ann Dormer Johnson.)

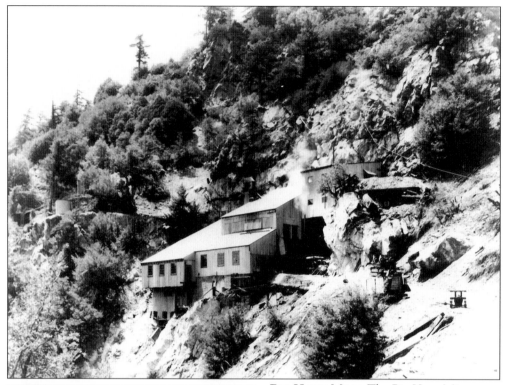

BIG HORN MINE. The Big Horn Mine was discovered in 1894 by Tom Vincent, a prospector and hunter. Clinging to the rocky eastern slopes of Mount Baden-Powell at almost 7,000 feet, the gold mine was active for about ten years in the early 1900s. Located six miles west of Big Pines, the mine has gone through brief renewals of activity over the past 90 years. (Courtesy Steele Photo Service, Wrightwood Historical Society.)

VINCENT'S CABIN. Tom Vincent was a rugged mountain man who built and lived in a rustic cabin high in Vincent Gulch from about 1870 until 1926. Vincent lived a reclusive lifestyle in the local mountains, not far from the Big Horn Mine that he discovered. (Courtesy Helga Wallner.)

Seven

THE SKI AREAS

In the mid-1930s interest began to grow in the sport of Alpine skiing. Downhill and slalom events became more popular than the Nordic events of ski jumping and cross-country skiing. The famous master jump at Big Pines was removed in 1940, and the junior jumping hill was converted to a toboggan slide. The first commercial ski development came in 1937 when Harlow Dormer and his partner Craig Wilson obtained a Forest Service lease for Table Mountain, one mile north of Big Pines, and there built the first rope tow in Southern California. A few years later Frank Springer and Tom Triol took over the management of the Blue Ridge ski area and began developing a variety of runs that would appeal to both beginning and advanced skiers. In 1948 Sepp Benedikter obtained a permit to develop Holiday Hill Ski Area east of Big Pines. He cleared runs, built rope tows, and started a ski school.

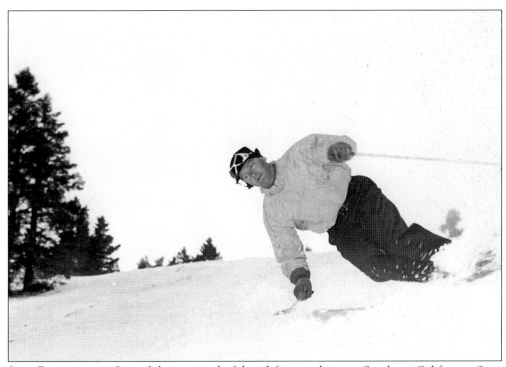

SEPP BENEDIKTER. One of the most colorful and famous skiers in Southern California, Sepp Benedikter is shown in action on the slopes of Blue Ridge. (Courtesy Marcia Myers.)

109

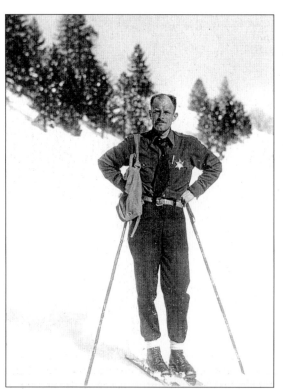

HARLOW DORMER. Harlow "Buzz" Dormer, an important name in local ski history, is pictured here. Arriving in Big Pines around 1934, Harlow was the assistant chief ranger for Los Angeles County at Big Pines Park for many years. (Courtesy Ann Dormer Johnson.)

SKI CLUB. On January 2, 1932, a group of Big Pines ski enthusiasts officially organized the Big Pines Ski Club. One of the inaugural members was Harlow Dormer. The club grew into one of the major skiing organizations on the west coast. Its purpose was to promote an interest in outdoor recreation and particularly snow sports in Southern California. (Courtesy Ann Dormer Johnson.)

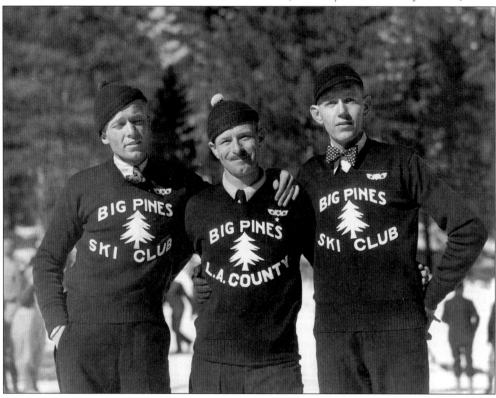

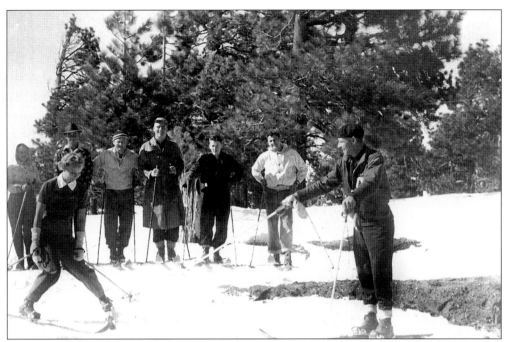

SKI SCHOOL. In addition to other duties, Harlow "Buzz" Dormer found time to give ski lessons at Table Mountain, where he had built the rope tow in 1937. Dormer was also the official photographer for *Trails Magazine*, a publication dealing with the history of the mountains of Los Angeles County. (Courtesy Ann Dormer Johnson.)

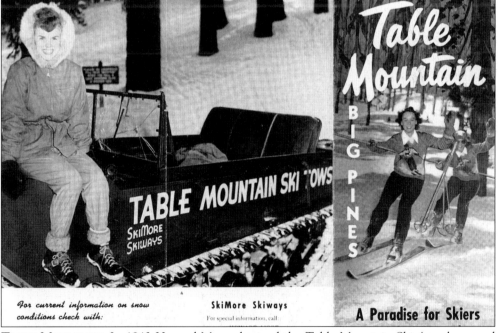

TABLE MOUNTAIN. In 1943 Howard More obtained the Table Mountain Ski Area lease and spent two years building rope tows and upgrading the area in readiness for his opening season in 1945. (Courtesy Marcia Myers.)

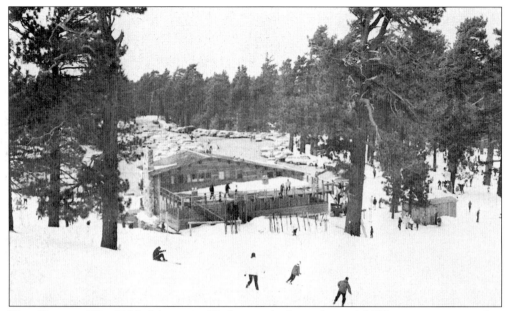

THE CHALET. The Table Mountain Chalet was built in the mid-1950s using native timber cleared from some of the ski trails. Wrightwood resident Bob Waag was the manager of Table Mountain for many years and played a significant role in building the chalet. Irma Waag ran the food concession and daughter Shari sold tickets. The photo shows the chalet and parking lot as viewed from Showoff Hill. (Courtesy Rich McCutchan.)

SKI SHOP. This is an early photo of the ski shop when boots could be purchased for $8.95. In 1973 Howard More sold the Table Mountain Ski Area to a small group of investors. The new owners changed the name to Ski Sunrise and Dave Ward became the general manager. Many improvements were made to the area over the next 20 years. In 1993, More regained ownership, which is still retained by the More family. (Courtesy Marcia Myers.)

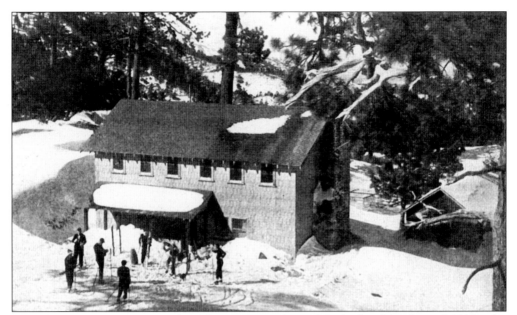

SKI CLUB HEADQUARTERS. When the Big Pines Animal Park closed in the mid-1930s, the buildings were renovated for use by the Big Pines Ski Club. Located about a quarter mile from the road leading to Table Mountain, the main building has a large lobby and fireplace, with dormitory sleeping quarters on the second floor. The building is still in use. (From *Trails Magazine*, Autumn 1937; courtesy Barbara Van Houten.)

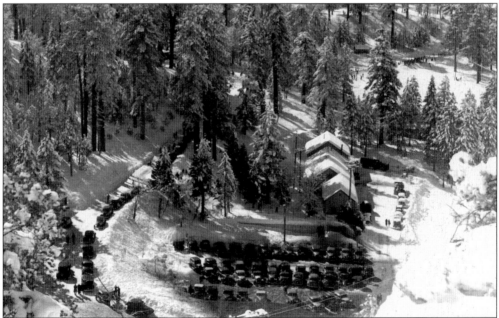

ROAD TO BLUE RIDGE. This corner where all the cars are parked was once the location of the children's playground, ball court, and swimming pool. Further back were three county maintenance buildings used for vehicle storage and repairs. In the far background is the mountain meadow. The road goes up to Blue Ridge, now Mountain High West. (Courtesy Huntington Library, San Marino, California.)

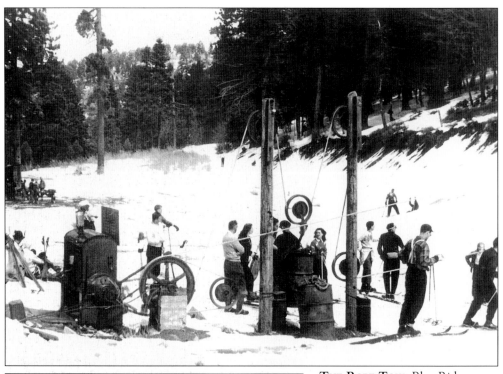

THE ROPE TOW. Blue Ridge was first operated with a rope tow. In the early 1940s, championship teams practiced at Blue Ridge, one of the oldest ski areas in the country. (Courtesy Marcia Myers.)

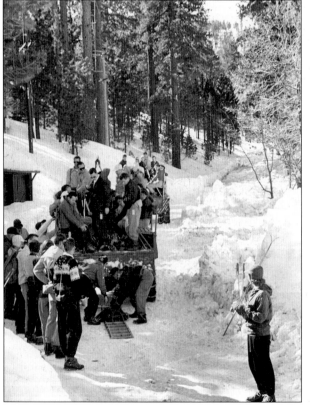

MODE OF TRANSPORTATION. The problem of the long walk up the hill to the lifts was solved by using two old Army trucks to transport the skiers. (Courtesy Marcia Myers.)

CHAIR LIFT TICKET. Here is an early chair lift ticket from Blue Ridge Ski Area. (Courtesy Marcia Myers.)

BIG PINES SKI LIFT CO.
Southern California's Best Skiing
85 MILES FROM LOS ANGELES

10 Rides for $4.50

The person using this ticket book assumes all risk of personal injury, or loss or damage to property.

Chair Lift

00762

GLOBE TICKET COMPANY

THE CHAIRLIFT. In 1947 Frank Springer and Tom Triol built the original chairlift at Blue Ridge. This was Southern California's second chair lift; the first was located at Mount Waterman. Tom Triol is shown loading the chair. Sepp Benedikter is on skis by the "weasel" vehicle, which took skiers from the highway up to the base of the chairlift. (Courtesy Marcia Myers.)

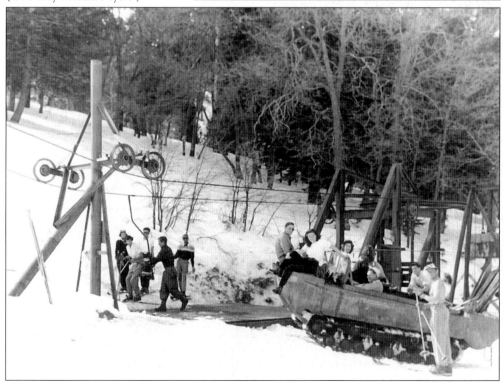

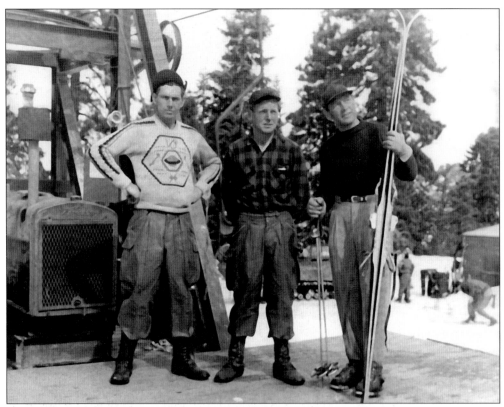

SKI PIONEERS. This 1947 photo shows, from left to right, Frank Springer, Tom Triol, and Sepp Benedikter shortly after completion of the new chair lift. (Courtesy Marcia Myers.)

THE SHUTTLE BUS. Jim McKee is shown driving a truckload of skiers up to the base of the lifts, c. 1952. (Courtesy Marcia Myers.)

THE SINGLE CHAIR. Marcia Springer Myers is pictured riding the single chair lift that ran from the bottom of the jump hill to the top of Blue Ridge. (Courtesy Marcia Myers.)

MAS-SKI-RADE. A popular event at Blue Ridge was the Easter Mas-ski-rade. This well-attended event featured obstacle courses, prizes for the best costumes, and fun for everyone. The partnership of Frank Springer and Tom Triol was dissolved in 1950, and Frank Springer became the sole owner. In 1975 Springer sold Blue Ridge, and the name was changed to Mountain High. The area later became known as Mountain High West. (Courtesy Marcia Myers.)

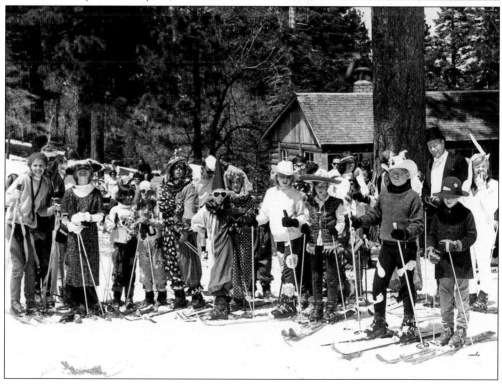

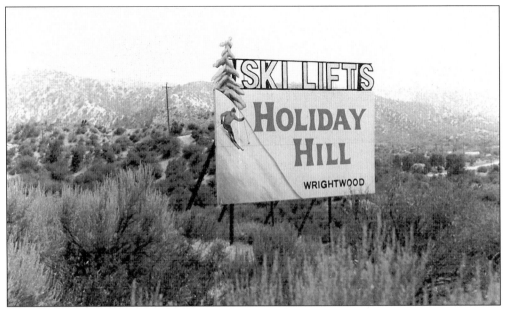

HOLIDAY HILL. Sepp Benedikter obtained the first permit to develop Holiday Hill in 1948. In 1950 Sepp and John Steinmann became partners and built a double chairlift, the longest in Southern California. In 1951 Steinmann bought out Benedikter, and Holiday Hill became a family operation with Steinmann's sons Heinz, Hans, and Kurt assisting with management and expansion responsibilities. (Courtesy Pat Krig.)

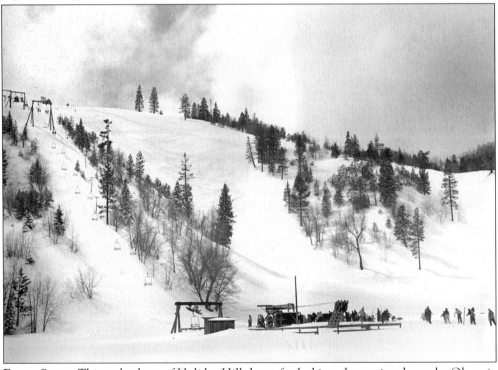

FRESH SNOW. This early photo of Holiday Hill shows fresh ski tracks coming down the Olympic Bowl. The double chairlift could carry 600 skiers per hour. (Courtesy Rich McCutchan.)

118

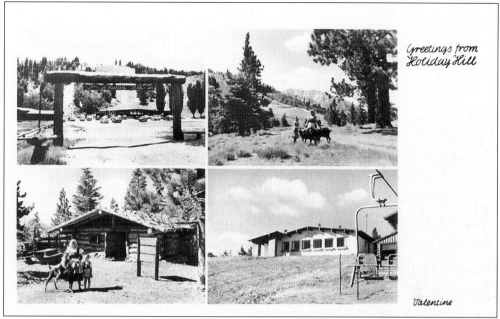

MANY ACTIVITIES. A popular attraction at the top of Holiday Hill was the Heidi House, a rustic log cabin built to resemble the house of the *Heidi* story. Live goats were on hand to greet the visitors. Also at the top of the hill was a combination restaurant and warming hut. (Courtesy Rich McCutchan.)

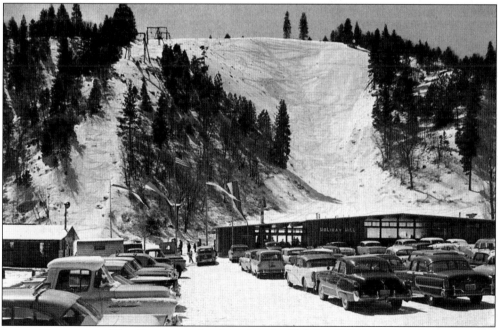

LATER EXPANSION. The Steinmann brothers bought Holiday Hill from their father *c.* 1959, then around 1962 Heinz bought out his brothers, and he and his wife, Lora, became the owners of the ski area. Many improvements and expansion of the facilities took place throughout the 1960s and 1970s. (Courtesy Rich McCutchan.)

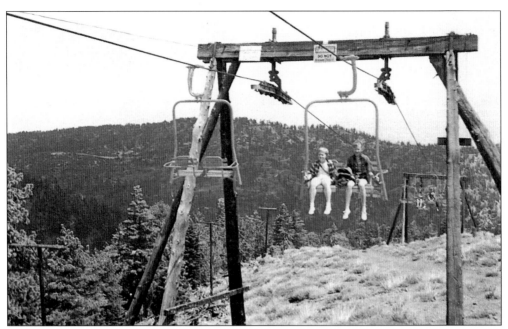

SUMMER RIDES. During the summer months many visitors to the area enjoyed scenic chair lift rides. Around 1979 the Steinmanns sold Holiday Hill to a group of investors, who re-sold it in 1981. The area is now known as Mountain High East. (Courtesy Rich McCutchan.)

MESCAL SNOW PLAY AREA. Snow play was part of the winter recreation scene. In the early 1960s Al Myers obtained a Forest Service permit for the Mescal Snow Play Area. Located one quarter mile west of the Big Pines Ranger Station on Big Pines Highway, the area provided groomed and patrolled toboggan runs. In later years the area was operated by Herb and Dorothy Bentley. (Courtesy Rich McCutchan.)

Eight

LATER YEARS

In the early 1930s the Los Angeles County Board of Supervisors realized they were in financial trouble at Big Pines Park. They could no longer afford the large expenditures needed for the mountain resort. Along with rising maintenance costs for many of the facilities, the effects of the Great Depression had taken their toll on county finances. In 1934 the board proposed that the U.S. Forest Service take back control of the park. In 1940 after years of negotiations, the Forest Service cancelled the permit for the government lands under the county's control. The takeover by the Forest Service took place over a 12-month period. Contrary to many inaccurate stories, the county did not take equipment and supplies that the Forest Service needed. According to Harry Grace, Forest Service administrator of Big Pines in 1940, the transition was worked out by mutual agreement. On July 1, 1941, the few remaining county employees left Big Pines in a large convoy of trucks and cars. The heyday of Big Pines Park was over. Fifteen years of fun and excitement had come to an end.

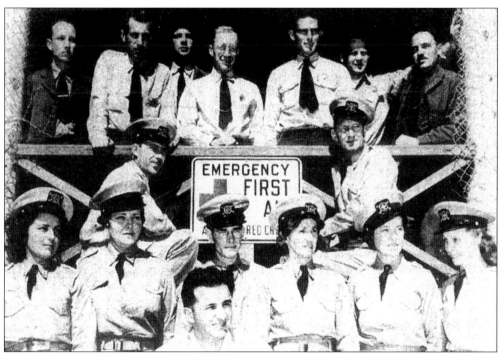

FOREST SERVICE, RED CROSS PERSONNEL. In this 1941 photo, from left to right, are (top row) Harry Grace, Jack Schou, Ken Bower, Jay Swarthout, Ned Taylor, George Ramstad, and Howard Rowe; (front row) Red Cross personnel who helped with winter sports injuries. (Courtesy Harry Grace.)

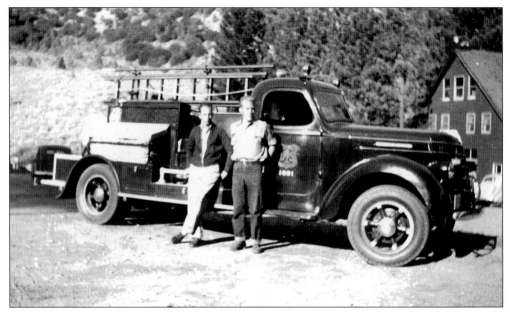

1939 FIRE TRUCK. This is the 1939 Wrightwood/Forest Service fire truck. The townspeople bought the chassis, and the Forest Service built the tank on it for use on forest fires and residential structure fires. Harry Grace is on the left; Curtis Jones is on the right. (Courtesy Harry Grace.)

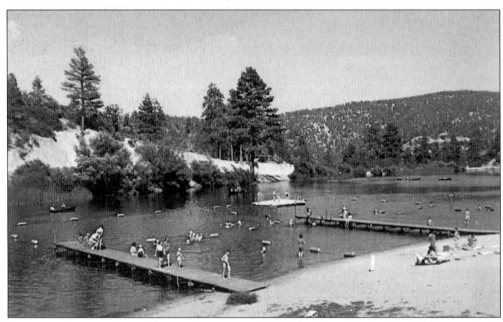

IMPROVED JACKSON LAKE. During the summer of 1940 the Forest Service hauled in many loads of sand to the south side of the lake, cleaned out the cattails and willows, and created a nice swimming area, which was greatly appreciated by the organization camps and forest visitors. (Courtesy Rich McCutchan.)

FIRESIDE INN. Built in the late 1940s, the Fireside Inn was a popular restaurant, bar, and dance hall. The inn was on the corner where the earlier Big Pines swimming pool and playground had been. Customers could dance to the music of locals Ed Thomas, Dan Burns, and Johnnie Clark, or sit and watch the deer browse in the meadow. The inn burned down in 1959. (Courtesy Mary Etta Hanson.)

BIG PINES CHANGES. During the World War II years, many activities at Big Pines came to a standstill. New life was brought to Big Pines in 1956 when the Angeles Crest Highway was completed. The Forest Service placed a higher priority on recreation. New campgrounds were built, trails were cut, and the old lodge became the Big Pines Ranger Station. (Courtesy Russ Leadabrand, *Guidebook to the San Gabriel Mountains of California*.)

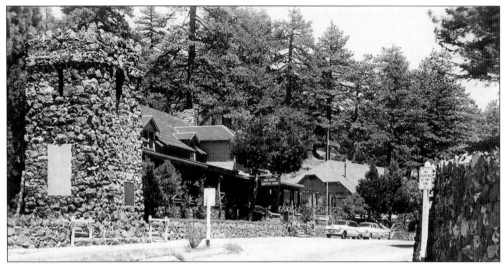

DAVIDSON ARCH REMOVED. In 1950 the Davidson Arch was removed in anticipation of the Angeles Crest Highway reaching Big Pines. The reason given for removal of the arch was to allow large trucks to pass through the intersection and to widen the road. All that remains now is the north tower. (Courtesy Rich McCutchan.)

BIG PINES STATION. Steve Servis, Forest Service ranger, left, and Fred Marshall, Big Pines registrar, confer on the steps of the ranger station in 1965. This building also served as the Visitor Information Center. (Courtesy Roger Marshall.)

ON PATROL. In 1974 co-author Barbara Ballard Van Houten was hired by the Forest Service to work at the Visitor Information Center at Big Pines. A summer assignment in 1976 was to patrol the forest areas around Wrightwood and below Big Pines. Working at the Visitor Information Center fostered a keen interest in the Big Pines area and eventually led to the co-authorship of this book. (Courtesy Barbara Van Houten.)

SUMMER SCENE. Looking down over the San Gabriel Canyon, this beautiful oil painting by renowned artist and longtime Wrightwood resident Dillie Thomas depicts the scene from Inspiration Point, two miles west of Big Pines. (Courtesy Dillie Thomas.)

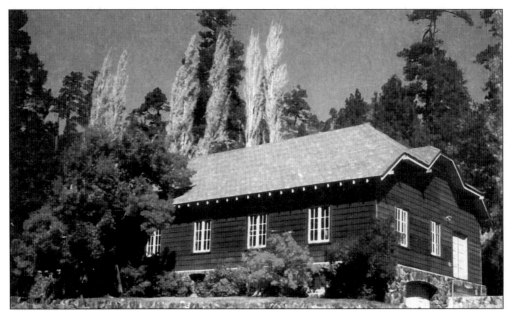

THE LODGE. In later years the old Big Pines Lodge was turned into a Visitor Center, first aid room, offices for Forest Service personnel, and a large storage area where the dining hall had been back in the 1920s and 1930s. Thousands of visitors came to the center every year, seeking information about Big Pines, which has become one of the most heavily used areas of the Angeles National Forest. (Courtesy Helga Wallner.)

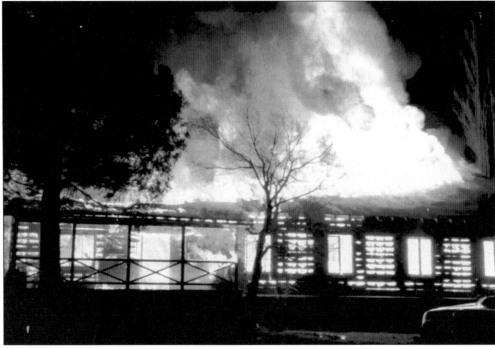

DEVASTATING FIRE. On February 17, 1987, the old lodge and current Visitor Center was burned to the ground by an arson fire. Along with many wonderful memories, the fire destroyed valuable historical files and photos. (Courtesy U.S. Forest Service.)

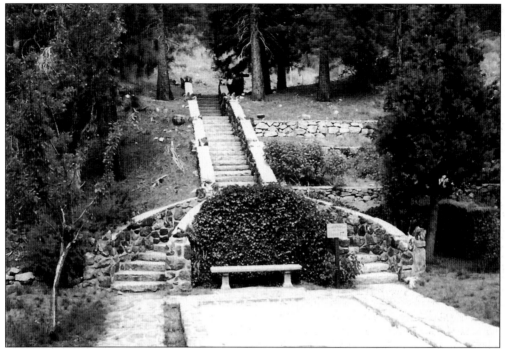

ONE AREA SAVED. Saved from the fire was the patio area where the reflecting pond and the original stairs that led up to the rental cabins were located. This patio was located between the lodge and the Recreation Hall. (Courtesy Barbara Van Houten.)

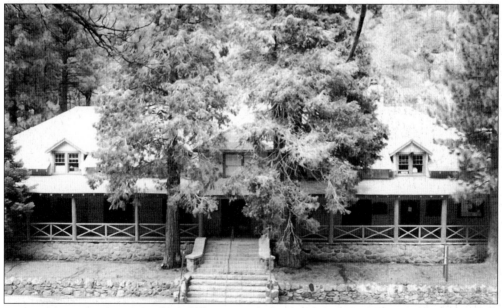

RECREATION HALL, 2004. The hall has recently been renovated and restored to its original condition, right down to the color of the paint. The work was done by crews from Fenner Canyon Conservation Camp under the supervision of dedicated volunteer Bill Cone. This building now looks much the same as it did in 1926. Perhaps we have come full circle with the majestic old Recreation Hall left for us to enjoy. (Courtesy Barbara Van Houten.)

ACKNOWLEDGMENTS

Many people helped tell the story of Big Pines, and their assistance is greatly appreciated. Thank you to Rich McCutchan, who allowed us to use his wonderful Big Pines and Wrightwood photo collection; Erin Chase, the Huntington Library; Dace Taube, University of Southern California; Bruce Guter and Susan Hutchinson, Pomona Public Library; Carolyn Cole and Bettie Webb, Los Angeles Public Library; Carol Turley and Octavio Olvera, University of California at Los Angeles; Wrightwood Historical Society; U.S. Forest Service; and the personal photo collections of Dan and Joan Burns, the Preston Butler family, the Corpe-Krig families, Walt Doan, Harry Grace, Mary Etta Hanson, Ann Dormer Johnson, Christine Lange, Russ Leadabrand, Jody Lopez, Roger Marshall, Marcia Myers, Ed and Dillie Thomas, the late Helga Wallner, Camp Hemohme and the Lions' Camp at Teresita Pines

Thanks to the following for the oral interviews that provided so much history of the early days at Big Pines: Harry Grace, retired Forest Supervisor and Forest Service administrator at Big Pines in the early 1940s; Walt Doan, who lived at Big Pines from 1929 to 1935, Ann Dormer Johnson, resident of Big Pines in the 1930s; and Doug Milburn, currently the assistant forest archeologist for the Angeles National Forest. Ingrid Wicken's research into the area's early ski history was most helpful, as was John W. Robinson's history of Big Pines and Wrightwood.

Special thanks go to my niece, Dani Quinn, who scanned all the photos and gave excellent technical advice; to my mother, Helen Reece Ballard, who listened to endless stories of Big Pines at the dinner table; and to my patient husband Fred who drove me all over Southern California collecting photos, typed the text for this book, and encouraged me every step of the way. Thanks to everyone!

—Barbara Van Houten

No way could I ever say "thank you for all your help" to all the people who so willingly took the time to look through albums, dig through boxes, to assist in this endeavor. But it's time to name a few of you: Dani Quinn who put all the pictures into her "Magic Machine" and scanned them; GeorgeTillitson, who scanned and printed with "the speed of light"; Arin Coyl, who gave himself carpal tunnel doing all the typing for me as I read to him; Virginia and Bob Hallanger and their lovely nieces, Nancy and Leslie, all Kate Wright relatives; Bill Hillinger, a great photographer; Dillie and Ed Thomas for the loan of pictures; Rosalie Johnson and Bob Clyde, fortunate owners of an historic old ranch; Fred Moulton for the pictures of German Village— they even had a relative who trained there! Don Bowman for restoring the old tractor; the Wrightwood Historical Society for allowing the use of their archives; and last but not least, two superb early photographers, Frasher and Fiss. Thanks to one and all.

—Pat Corpe Krig